# Grazer Kunstverein

# Writings and Conversations

## by Doug Ashford

# Mousse Publishing

# Table of contents

## Preface

This publication represents one of the many spaces
Doug's work occupies. It is a collection of writings and
conversations that attempt to comprehend the thoughts
and concerns shared by the artist over the past
twenty years.

Looking back at some of the many emails I have
exchanged with Doug over the past year, I am struck
by how fast we became intimate with each other.
I knew the legacy of Group Material and its impact on
current artistic, curatorial and social practices, but
of Doug's work, I was largely only aware of his talks and
writings on social and political collectivity. In fact,
Doug's creative life over the last 20 years was primarily
involved in teaching but then gradually became filled,
almost unknowingly, with the production of his own body
of work. In a recent interview with curator Maria Lind,
she rightfully introduces to this process the etymological
term *abstrahere*, which in Latin means "to withdraw,
to step aside", a term most applicable to Doug's personal
as well as professional life. Group Material's joint
efforts to address social and political issues made way
for a more singular solitary voice, still deeply rooted
in the abstract investigation of the collective but focused
on a more distant and reflexive perspective. His immedi-
ate environment became a grid for studies on shape
and color, such as in the painting he made for his close
friend Andrea Geyer, which portrays her surroundings
and inspirations in a schematic manner. Abstract forms
became the language Doug used to understand the

relationship between the personal and political.
The physical size became a direct intimate translation of
this understanding; painting delivered as a text, archive
or photo at a humanly manageable scale.

The subjects addressed in these pictures explore
the aftermath of a collective (often political) crisis filtered
through newspaper clippings and archive imagery.
While Group Material addressed similar large social issues
presented and discussed collectively, Doug's paintings
stem from a quieter and more formal voice. His writings
represent a mixture of both methods; from analytical
texts on the intentions behind Group Material's methods
to a more poetic reflection on personal subject matters.

When I think about Doug's earnest intentions,
the word "care" comes to mind. He sincerely cares
but also questions what that entails. What causes people
to respond empathically to one and another? And why
only after the occurrence of certain events? What do
"We" actually produce? One of Doug's essays is titled
"An Artwork is a Person", which typifies his position and
interest in questioning how an artwork acts as a social
vessel, something that has the capability of introducing
new languages in order to ask what it might mean
to become someone else.

A person is an artwork.

Krist Gruijthuijsen
director, Grazer Kunstverein

# Maria Lind Talks with Doug Ashford

Maria Lind's work as curator and writer spans a trans-formative history that parallels much of the infrastructural shifts for the production and display of art that the essays in this volume address. The constellation of practices and beliefs that she embraced has always placed art at the foreground of social invention. By making the intentions of artists actualized in ways sometimes never imagined, her sense of the curatorial can be seen as a resistant narration of social institutions and their histories; a re-invention. She began a conversation with me on the relationship between political organization, history and visual form in the spring of 2010, and our ongoing interaction has changed much of what I expect in my work. This interview, excerpted from a longer discussion that took place in the winter of 2013, is its latest manifestation.

Maria Lind: A highlight for me from last summer's Documenta 13 remains your work *Many Readers of One Event*, 2012, a series of small, abstract geometric paintings with black-and-white photographs of people who are physically supporting one another. They were installed in one of the huts in the Karlsaue park, with a glass front so that they could be seen even at odd hours, hanging on the wall and leaning against shelves. How did you come to make this work?

Doug Ashford: The project started with a desire to try to create a more theatrical experience of concerns than I have had in the past in singular paintings. It involves a tableau that proposes multiple points of view on the documentation of a particular catastrophe. This is connected with an open-ended question of how we respond to the disasters of the present.

The documented event I began with was a particularly awful experience of a group of parents finding their dead children in a Camden, New Jersey parking lot. In the installation, there is a single news photograph from the New York Times of the parents collapsing in each others' arms at this discovery. All of the many other photographs in the project are of actors re-enacting this physical pose, of people grieving to the degree that the coherence of their body gives way.

Corresponding to those re-enactments is a series of eighteen paintings that explore how abstraction and identification work together to inform human responses and politics. These works embody a way of looking simultaneously at two different kinds of intellec-

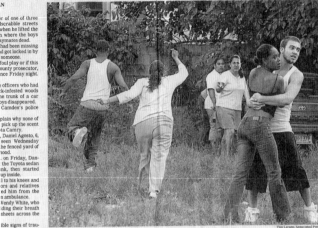

Shock in a lot next to the home of a missing Camden boy, Anibal Cruz, after the trunk of an unsearched car was

Tim Larsen/Associated Press

Inside page from *The New York Times*, June 25, 2005.

tual organization of affect: one identifying with an experience (the act of empathy) and another that is off-center, examining the ways in which abstraction might create a condition for sharing an experience of something without a reference.

ML: One way of understanding abstraction today is to look at its etymology. *Abstrahere*, in Latin means, "to withdraw, to step aside." This stepping aside from the mainstream by many artists and other cultural producers is a new form of performative, social abstrac-

13

tion. It seemed to me that the way you used the hut in the park was unusually well-suited to the body of work, as if it was a jewelry box closed to itself. What is the lure of abstraction for you?

DA: The hut's isolation is related to the idea that abstraction has the capacity to model things in ways that become difficult to instrumentalize, redefining utility. As a cabinet or an aquarium, the glass-fronted house served as a way to look at documented facts as concurrent with the ideal models of abstract pictures.

Part of my background is in creating exhibitions with the collective Group Material. In a sense I'm always

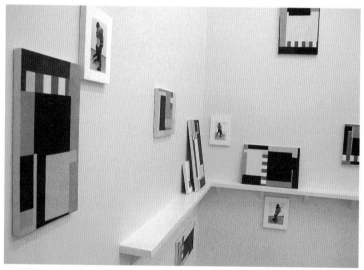

*Many Readers of One Event*, 2012.

in the audience, and the experience that I have as a producer of these pictures is still related to aspirations I have about how audiences can question social meaning through the condition of display. In this case, it's an experience that I'm hoping will create an emotional response in which people are able to share those mediations of feelings with each other and see them as something that might actually change historical conditions.

ML: Certain abstract traditions, for example Constructivism, have arguably employed abstraction with the instrumental aim of creating a better human being, not to mention a better society *tout court.* There is still a trace of this mix of idealism and utilitarianism in your approach to abstraction, which links back to Group Material. You have described your trajectory in terms of community identity: starting from addressing the social together with your peers through its own methods, to having to step outside of the social in order to continue to talk about it. Can you elaborate a little bit on that?

DA: We live in a time in which abstraction, as a programmatic condition of modernist economies, has taken on an overwhelming and oceanic darkness. The violent terms of the debt economy have made finance the sole determination of who and where we are, even before we arrive. But strangely, at the core of democracy there is another, perhaps inverted, aspiration of abstraction: the idea of the empty room of politics. This is a non-specific space where nothing exists other than agonism.

Known as the parliament, the forum, the congress hall, it is a place that demands to be filled with forms— with anything that can be said within the conditions of that room. From that place, ideas about how history could change or how subjectivity could reform itself would become thinkable.

ML: Abstraction as an agent of political change is clearly not new, in general or for you. Among other things, you have talked about Group Material's exhibition designs as being abstractions. In what sense were they abstractions, and how do they relate to your current abstract geometric paintings?

DA: In a sense they are both models, proposals. For instance, *AIDS Timeline* [1990] quite concretely placed abstract models of temporal experience and memory in friction with official history. In other words, as one walked through the exhibition, one could see the effect of the virus as a health condition, but also the way that media, government, and medical indifference created an actual epidemic; an epidemic of disbelief, but also an epidemic of despondency, one that wrecked our physical and social health. For me, the form of the exhibition could help reorganize hope. By investing in a reservoir of non-specific feeling that is created through abstract form, we can see ourselves as more than instruments produced by ideological contexts. Within the exhibition room, Group Material could propose a display as an abstract matrix of different conditions for the real, re-diagramming possible relationships to power.

ML: The way you address both your current work and the Group Material exhibitions as models in some form is very relevant. Part of the power of abstraction today— which might seem at first glance as an obsolete visual language, style, or phenomenon—has to do with the projected, with the capacity to imagine. Many people feel the need to think more actively about the future, about models, about prototypes and possibilities, and here abstraction still seems full of potential.

DA: But also as an actual political process. What we learned from the Occupy movement was the idea that you could refuse to be specifically represented in terms of an agenda or a program of effectiveness, and still take a position that is sincere and robust. This lack of specificity, presented as fundamental to social change, offers the possibility of agency outside of existing institutional terms of "usefulness."

ML: Your current way of working, in the withdrawn soli- tude of the studio, is radically different from the collective work you did with Group Material. This reminds me of the icon painter Andrei Rublev, the titular character in Tarkovsky's 1966 film, a figure who is immersed in this lonely activity and completely focused on delicate, handwrought images. What is the significance of process in your paintings?

DA: I was taught that the artworks that existed before me are still as contemporary as anything present in my own time. And in this anti-historical perspective on the

production of art, I am never really alone. Your reference to the Tarkovsky film is really interesting to me because Rublev, and the circumstances of Byzantine painting, propose a painting-object that could exist outside of the fixed conditions of display. If icons are paraded through the streets, they might become part of our daily decisions and begin a kind of theater of confusion and choice. I'm interested in similar experiments in the revolutionary Soviet work of Gustav Klutsis, who made works that could be carried into the streets or held in your hands as both representation and as a suggestion of new life. This simultaneity of abstract sign and ethical imperative, of public interaction and an open field of abstract construction, were extremely influential to me early on. That's why I made the shelf in Documenta, to suggest that an abstract painting could become a tool, an instrument like any other. As potentially moveable or stored panels, those paintings could be understood as an archive that could be physically handled, and projected onto.

ML: What is the significance of your precise aesthetic articulation, the technique you're using, the shapes you're opting for, the colors you decide to employ?

DA: It really depends on the work. For *Six Moments in 1967* (2010–2011), which offers six photographs of political manifestations in the street in each of the six paintings, the implementation of colors and shapes was an attempt to replicate the optimism of the grid; to try to see the grid as a conversion of subjective experience into

an objective form that could be measured in relationship to a memory of a political event. Identification with the demonstrations documented in the photos impressed upon me a color imperative in which variations on a dark blue would be organized around the aspirations of those involved. The colored shapes are painted over and over again as an attempt to convey, excessively, what might have happened through political action.

ML: What about the intimacy of the paintings?

DA: I can't make a big one. There is something important to me about looking at a painting as a text, as an archive or as a photo album, as a place in which you are reading through an intimate relationship with someone else's memories or experiences. Tempera creates a depth of color, but at the same time it's extremely flat. The flatness for me establishes a position of looking carefully at something that is representing no *one* thing in particular, that is an abstraction. The material production of the painting aligns with a certain mode of attention, a desire to decipher the past while painting over or painting through real conditions, as if making a picture allows the possibility of remaking those facts.

ML: One interesting tension in your paintings I think is between precisely geometric abstraction. It's not rectilinear. It's not perfect angles and in that sense it is still handmade. You can feel slight, delicate deviations, which underline the idea of emotion and empathy. Typically, we would think more of gestural abstraction

being connected with the emotional. But you have referred to both Hume and Wilhelm Worringer, the German art historian, and specifically the latter's thesis, "Empathy and Abstraction" from 1907. One of Worringer's ideas is that abstraction allows us to go beyond identification, creating what you have called off-centered meaning. I'm curious why this is important to you and how it relates to love as a political concept, which you have also been writing a bit about.

DA: The complication with empathy as force of identification is that "feeling-into" the experience of others suggests, quite strangely and perhaps even violently, their replacement by us. As my friend Claire Grace once appealed by questioning the prevailing colloquialism: "But when you are 'in my shoes,' where do you make me go?" One possible way to think beyond limited forms of identification would be to be put oneself into a position of continual displacement; moved into positions of connection to the point of contradiction so great that it demands abstraction. It seems to me that democracy has always had this kind of demand.

In a way I think I have re-written Worringer through some kind of artist-reflex in order to make his ideas match my interests. I purposively misrecognize his divisions between empathy and abstraction and present them as potentially simultaneous experiences. I want naturalism to coexist with the kind of non-objective understanding that can happen through abstraction. For instance, when I make my way down a street full of figures, they appear to seek to be "themselves"

through advertising as much as through belief. In this contemporary condition, identity seems capable of being formed in the abstractions of dominant culture's media imagery and financial ethos before even being considered. Maybe Worringer's idea of abstract form overcoming the dread we have with the world can be relocated in a place where others become part of an imaginative addendum to the self, an ongoing inclusion of irrational identifications that are never defined as real or realizable.

Or, as we kind of always know in some way, there is level where affiliation and love point to contradictions that demand politics. We *feel* people as ideas that are transportable onto dreams and then back again into reality. Love presents us with the need to condition our association with other people in ways that are often unexpected. That unexpected rupture around love happens, I think, most consistently in conditions of catastrophe, when our finitude becomes palpable. That's why I am now involved in researching and photographing actors who enact contexts in which they are performing a physical collapse that corresponds to where a coherent sense of the self would appear to be falling apart. This fragmented self is for me, contiguous with early twentieth century conceptions of psychological abstraction that inspired Worringer. It is a physical concept, necessarily embodied in objects, beyond any unified identification and where affiliation or love can become the basis for a new body or form. Once somebody is in a form that denies a unified and stable self— and this "my Worringer"—the consistency of helpless-

# Abstraction
# and Empathy

This essay is an excerpt from a longer text written for a presentation at the New Museum in New York City in April 2011. The work was composed as a reading to be interwoven into another piece of writing by Angelo Bellfatto, one my oldest and closest friends. Angelo's thirty-year sculpture and painting practice, although rarely publically presented, has had a tremendous influence on me—and many others. The resulting co-performance was basically two intimately related people finding connections with each other's practice in public. With Angelo's example, links became newly describable between my involvement with Group Material and my still emerging understanding of painting, which had begun to occupy me ten years before. Presenting these speculations alongside someone I love allowed for a different kind of exploration of the more difficult emotional contexts of artistic production and intention, than in the past.

What I have been trying to think about this year is something quite simple—how the relationship we have with art can make us more human when it shows things beyond what society allows us to experience. How through art we can see beyond the horizon of learned expectations. For me this thinking is a bit of an evolution. Most of the work I have done until this point in my life has been based on existing art objects and artifacts collected and then re-organized to suggest the possibility of emancipation. These days I'm trying to make things a little differently, as discrete objects that approach my previous concerns somewhat tangentially.

This production is awakening questions that I have long held on the relationship between abstract art and the feeling we call sympathy or empathy. I'm starting with a great student of emotions, the philosopher David Hume. He thought a lot about the way that perceptions of the world could diagram the close yet failing connection between morality and emotion, when described in our senses and embodied in our poetics. He said, and I am paraphrasing here, about the correspondence of human souls: "As soon as any person approaches me, he diffuses onto me all his opinions and draws along my judgment to a greater or lesser degree. And though, on many occasions, my sympathy with him goes not so far as to entirely change my sentiments and way of thinking, it seldom is so weak as to not disturb the easy course of my thought. The principle of sympathy is so powerful and insinuating a nature that it enters into most of our sentiments and passions, and often takes place under the appearance of its

Preparatory drawing for *Portrait of Andrea Geyer*, 2006.

contrary. For it is remarkable that when a person opposes me in anything and rouses up my passion by contradiction, I always have a degree of sympathy with him, and my commotion cannot proceed from any other origin." Hume is saying here, I think, that the differences we have with each other are always in a state of being overcome, interrupted by what we have in common, and this commonness is discoverable in the mere fact that we confront alienation in every meeting.

Nonspecific and removed, abstraction is often understood as a purposefully limited relation between

humans and their ideas—cutting our sense of things in order to approach their complexity without a full description; disdaining legibility to open richer, multiple readings. It is as if abstract imagination seeks to allow something lost, or something too big to see at once, to creep into our daily vision. The strange thing is that when this happens successfully—we do more than see differently—we feel differently. We can understand more when looking through the loss that abstraction removes. This survival is made understandable through mediation with objects, and in particular with objects we call artworks—things that present a world that before they arrived, was indifferent to our feelings.

When I think about how art shows human survival, I am reminded of times I have spent sharing the desperation of political urgency in collective dislocation. The sharing of dislocation, of looking for a new place in which to consider our lives, can produce an aesthetic epiphany. But how does this work? I'm wondering what it means these days to employ abstract images as a participant in social organization efforts. For many years I was a collaborator in Group Material, an artistic process determined by the idea that social liberation could be created through the displacement of art into the world, and the world into the spaces of art. We saw our designed exhibitions as a way to picture democracy— and although anchored in activism, we wanted our projects to live in the worlds both within and without the field of art.

Today I'm interested in how Group Material's exhibition designs was used to assign democracy's

unpredictability and inclusivity to an imaginable shape—
a shape you could feel, a shape that is always irregular
and fluctuating: an abstraction. This was and still is,
an affecting proposal for the politics of real life: an aes-
thetic invention that evinces life's practical dilemmas
as a dream we are working through. But what is
the nature of this irregular shape? And if it is abstract,
a term suggesting withdrawal—from what does it remove
itself? What is it showing outside of depiction? In examin-
ing the social practices of my past, one thing that
becomes increasingly clear is that abstract imaginings of
social experience enable the consequences and contin-
gencies of our political imagination to open up to fantasy.
This shift allows the refiguring of both artistic and
social reinvention.

I'm wondering that if an abstract fantasy can
partially deny reference to actual life, then maybe it can
go on to offer another kind of solace, another chance
for action. As the forms of actual life are forced to filter
through the ideal projections of abstraction, life itself
can be repositioned, moving our concepts and our bodies
into contexts of self-design. This suggests the possibility
of creating a distinction between the emotions that
are designed for us by the world of power and domination,
and new feelings that can be built independently.
After all, we are each overflowing with the obscurities
of memory, the stunning misrecognitions they produce,
our exchanges with one another, the use of ourselves
by others, the use of ourselves by our selves, our
dreams of our helplessness newly recognized together.
Art repeatedly demonstrates that we can put these

autonomous senses together into new things—things we can look at and talk about.

I might be confused here between an art that is abstract in its excessive inclusion (movement overflowing with agency) and an art that reveals something previously unknown by excluding references to the real. But maybe there is a way to get from one to the other. My experiences with exhibition design presented collections of art as places where social mutuality and personal antagonism could both be embodied. And that embodiment signals the possibility of turning away— or toward other things, other people.

This was equivalent to viewing oneself through a variety of bodies and positions, looking through another's eyes across vistas, toward this or that event, or even inwards. There was a Renaissance notion that one could occupy the eyeballs of another through a perspective delineated in an artwork. It assumed that through transubstantiation, we might encounter something beyond the possible. Its shock was related to the formal and physical presence of a stranger, and it is difficult to discuss rationally, since immersion in another person is so much more than the strict diagramming of corporeal perspective, the agreement or disagreement with a position. Instead, we are faced with the rearrangement of all our sensibilities into something outside of us, finding the self in another. Once achieved, such identification can be invested in finding even farther things, feeling difference across even larger boundaries.

This is certainly an old idea, one alluded to in the David Hume quote I paraphrased earlier, and beautifully

re-diagrammed by the art historian Wilhelm Worringer who wrote at the very beginning of the 20th century. He insisted that identification outside of the self and with another is pivotal to all aesthetic experience. In fact such power exists only *because* of its representation in art. Without art, we flounder in oceanic solitude, unable to look away from ourselves.

Worringer said, quoting Goethe:

"The Classical feeling for art has its basis in the same fusion of man and world, the same consciousness of unity, which is expressed in humanity's attribution of a soul to all created things. Here too the presupposition is that human nature 'knows itself one with the world and therefore does not experience the objective external world as something alien, that comes toward the inner world of man from without, but recognizes in it the answering counterpart to its own sensations.'"[1]

Worringer went on to insist that we must see the world as, "counterpart to our own sensations." Departing from philosophy, he arrived in a world of psychological mysticism, trying to figure out what it means to lose and re-find the self in sensual experiences. One important document of this journey is the essay, "Abstraction and Empathy, A Contribution to the Psychology of Style," from which I have just quoted. He goes on to state:

"The need for empathy can be looked upon as a presupposition of artistic volition only where this artistic volition inclines toward the truths of organic life, that

31

is toward naturalism in the higher sense. The sensation of happiness that is released in us by the reproduction of organically beautiful vitality, what modern man designates beauty, is a gratification of that inner need for self-activation . . . aesthetic enjoyment is objectified self-enjoyment. The value of a line, of a form consists for us in the value of the life that it holds for us. It holds its beauty only through our own vital feeling, which in some mysterious manner, we project into it."[2]

This sensibility that Worringer is naming is a reassessment of experiences that his predecessors called beautiful—experiences of the world that could overwhelm. And he compared this to the feelings of identification with other people that Hume outlined for us earlier, to sympathy. Why do we gain sympathy in the presence of complex objects? How do they move us? Worringer believed we change ourselves in two ways when faced with the world: in alienation from it, but also in identification with it. He believed the success of art, its complexity, derives from the negotiation of these two points.

Part of Worringer's project was to set out to distinguish our sense of empathy in art by separating it, opposing it to another sense of visual organization: abstraction. Where empathic experiences of beauty are volumetric and accepting, abstractive experiences are flat and insist we project into other models. Where empathy is a solitary position, abstraction is collective. Empathy is naturalism; abstraction shows the possibility of style. It is important to note here that the English

term 'empathy' as I use it now, is an inadequate translation of his German word, *Einfühlung*: "feeling-into." Worringer attached this sense specifically to the imagery associated with classicism and naturalism, forms of art we can *feel into*. By recognizing ourselves in images of each other, we are changed in some fundamental way— allowed to feel the structure of humanness.

It is important to see in this instance that abstraction could be understood as a sense that is in opposition to "feeling into"—abstract as anti-naturalistic and based in thoughts could make experiences where empathy would fall short. Abstraction, not against representation per se, was a form of art that Worringer considered newly generous, capable of presenting humanity outside identification, beyond the other we predict in ourselves. This is a place he thinks we need to go to at times in order to see the external world as changeable. He says:

"While the tendency of empathy has as its condition a happy pantheistic relation of confidence between man and the phenomena of the external world, the tendency to abstraction is the result of a great inner conflict between man and his surroundings, and corresponds in religion to a strongly transcendental coloring of all ideas. This state we might call a prodigious mental fear of space."[3]

Such an abstraction is still emotive then—but a production of feelings that can reconcile our apprehension with the outside world. Things outside us, Worringer implied, need to be redrawn to overcome our anxiety in their

presence—rediscovered in collective experience and individual perception. To make an abstract image of the world, he said, is not to admit incompetence at depiction or mimesis but rather to embrace a psychological need to show the world as seen through the imperfect distortions of humanity. Perhaps this means that Abstraction and Empathy are opposite positions that absolutely must be held onto simultaneously. Maybe we can see them as two ends of the same magic wand. Abstraction known in addition to Empathy could deliver the outside world to us, as both fluctuating other and absolute difference.

How can I suggest then that abstraction is a rearrangement of each of us happening in another person? How can we have both the love that accompanies empathy, and the distance and comfort that abstraction delimits? How about a rupture with things that stabilize me? How about breaking me as a rational participant of the world as it is already organized, and pushing me towards a world that has not yet existed? Without experiencing this rupture perhaps we would never see anything at all. But even more wildly, maybe things would not see us. Worringer suggests that the world itself is adjusted or modified through our understandings and expressions of it. If empathy is the stabilizing embrace of oneself in another, abstraction is a resolution to experience ourselves in concert with the instability of the world; unstable, experimental, and provisional.

And this is obvious perhaps: that an unstable identification outside of the accepted norms of human experience could be inclusive and enfolding. What else

can we do when we don't really know how things really are? Or whether there are "things" at all? In many abstract presentations there is potential for a wide breadth of meanings in multiplicity or relatedness. This is an implication that is very important today—meaning that is off-center, that can't easily contain a declared position or that can be delivered from a distance; gaining the possibility of more space for the maneuvering or the naming of our selves, our collective work.

I want to understand an art that demands the dis-ordering of the world's restrictions; an art that demands a position of reversal or of turning around: away from the rationalization of everyday life, away from desire's contemporary expression in commodity and violence. This may seem like a turning away from the future. But it is not in order to ignore a future or any hope for future—only a turning away from the false certainty of progress that can provide a turning back to the present. Orpheus turned back; Walter Benjamin's angel of history turned back. This turning proposes that our conditions of subjection can be extended into things we love instead of the things we obey; and the responses of loved things can become an opportunity for changes in ourselves: stylizations, perversions.

This may be why love is seen as so in need of reclaiming and revitalization today—love as a way of seeing beyond the wreckage upon wreckage that makes the present. An abstract love would be something that could map the settings we are secretly familiar with in facing the world alone. Like empathy made absolute, or nature made complete in abstraction, love is a con-

dition from which we can always be forgiven and at the same time forgive ourselves—no matter how profane.

Art becomes a portal into testifying to our helplessness by allowing us the space to admit we are helpless together—proving that love can sometimes become a political concept. Abstraction more specifically gives us a sense that we can position this love inside visual forms that exist beyond reference, forms we invent outside of the existing spaces of power, outside laws and languages already built. What can we ever command when we remain statically centered in a rational acceptance of the "terms of the debate"? Our compromises with the promise of laws, and their supposed progress, lead us away from seeing each other.

By linking the feelings of love embedded in artistic experience to larger forms of acquiring knowledge, we touch the archives of social ideas, their homes. By asking audiences to re-make themselves without reference to the real in invented affection for others living and dead, we can show that art can overcome the humiliation of life's present organization. The magic wand of abstraction, when joined to empathy, provides both a release and an opportunity—a moment for the production of new frames for love. Together they make a frame for a third position, structured I would like to think, by the abstract images we can make from each other, with each other. After all the thinking and writing I have realized that in truth I began to make abstract paintings simply because I liked how they looked. They looked like the failures of my life lit up by possibility.

1 Wilhelm Worringer. *Abstraction and Empathy: A Contribution to the Psychology of Style*, trans. Michael Bullock (Chicago: Ivan R. Dee, 1997), 128.
2 Ibid. 14.
3 Ibid. 15.

# An Artwork is
# a Person

In 2003 I began to experiment with making visual diagrams of the artistic, professional and personal relations that surrounded me. The friction between history and memory was the origin for an attempt to visually model the collapse and collection of human relationships as a painted object-form that could be recognized and shared. Bright within all this mental imagery were my many years of work with Julie Ault, who was preparing to place the individual collections and saved remnants held by all the members of the Group Material into an archive housed in Fales Library of New York University. Ault's subsequent book, *Show and Tell: A Chronicle of Group Material*, demonstrates her remarkable intellectual care, sense of form, and belief in the complexity of the dispersed ego of a creative collective. Group Material's exhibition design, formally abstract and yet still specifically named, served as the origin of a new possibility in this essay written for *Show and Tell*. Collected within the always re-forming context of memory, this text presents the embodied artwork in exhibition as a way to see why abstract artistic agency always has a political demand.

"The impossible demand to start the revolution everywhere at once is replaced by the statement that communication is possible only at the moment when everyone changes places: when the individual loses herself or himself in the effort of showing an image to someone else." Colin MacCabe, writing on Jean-Luc Godard in 1980[1]

"Join us!" Protesters to onlookers, the March on the Pentagon of October 17, 1967

The dismantling of the progressive economic and cultural changes of the 1960s began in earnest in the 1980s, and Group Material's overall project was imagined in this period of attempted historical erasure. This book, *Show and Tell: A Chronicle of Group Material*, comes at a time of concentrated reflection on the complex political contours of art in the 1980s; fifty years after the world-changing disturbances of Berkeley, Newark, Prague, Nanterre, Watts, Alabama, and Stonewall. Today's ascendant culture of war and its accompanying economic collapse bring home many of the state designed public fictions initiated in the 1980s. That the majority must still live precariously and in deprivation suggests that the darkest fantasies of governmental and corporate coercion were actually quite gnostic: an improbable world of passive spectators forced to endorse a reality imposed on them by executive power. The publication of this book in 2010 is then doubly reflective—representing the work of a group of artists in the 1980s that modeled the revolutionary counter-culture of twenty years before.

Most of the members of Group Material were children during the rise of the civil rights, women's liberation, free love, gay power, and anti-war movements of the 1960s. Even if we were too young to directly witness the mass physical mobilizations rejecting state totality and corporate greed, the concomitant changes in ethos, fantasy and feelings were tacitly embedded in our practice. Group Material understood that the

liberation movements against colonialism, patriarchy and capital were connected to artist-led oppositions to institutional hierarchies between institutions, audiences and artists themselves. The process of re-imagining ourselves through the rebellious inventing of art objects was, in many ways, a continuation of a larger political momentum.

In this way 60s activisms and 80s interpretive enactments were more than the socioeconomic conditions for Group Material's work: they were the foundations of its aesthetic action. Activist politics presented a moment of collective refusal, but in that refusal came an identification with others, known and unknown. The desire for political change produces conjecture on a number of fronts, and conjecture necessitates affinity with others. Modeling a future by banding together amidst the interests of strangers is a legacy shared by the political imperatives of social organizing and the methodological sensibilities of artists. Although art and politics may still be routinely sequestered in the academy, these two find great sympathy with each other in the actual effective function of people's work to change their circumstances. Artists cannot produce unless connected with others: with those behind the creative acts coming before them or with newly apparent audiences that surround them, real and imagined. This social knowledge invested in creative work is therefore based on a projected kind of empathy—a sense of the ethical coming from imagination and hope. Such feelings are deeply connected to the inevitability of ethical empathy formed in oppositional social agency; its acts of protest and organization

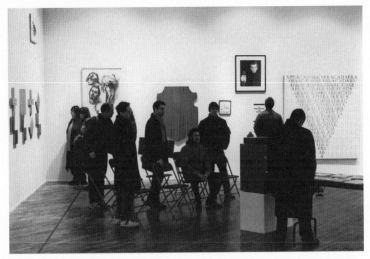

Viewers of *AIDS and Democracy: A Case Study,* Group Material, 1989.

are a genesis. That is why during the creative act, justice and beauty seem to come from the same dream.

For many of the actual participants however, memories of the movements of the 1960s are marked by its practical failures—the inability of majorities to recognize the potential liberation that those revolutionary movements and their counter-cultures could have provided. The tragedies of missed opportunities, internal sexisms, police infiltrations, capitulations and betrayals make for an almost unbearable chronicle. But the activism of the 60s might also make one inclined towards philosophical reflection on the subjective effects of non-governmental organization, a reflection that is encircled by aesthetics. An oppositional movement

makes groupings where the desires of others overtake
our sense of singular and individual autonomy, a process
amplified by protesting actions. If organized acts
of civil disobedience put people's bodies on the line,
then any sense of the continuation of the self is literally
and corporeally opened up to the proximity of strangers.
Anyone involved in public acts of political resistance
has had such an experience—the look toward another,
previously unrecognizable, but made familiar, even loved,
in the battle with gigantic repressive authority. The face
of the anonymous becomes empathically known.
This "new face" produces a fresh affinity under the duress
and risk of social unrest. It is an experience of the differ-
ence between humans at their most profound: an implicit
understanding that however far away liberation may

seem, we can still recognize its contours in the work
we do together. In times of rebellion, an encounter with
the desires of another person allows for the recognition
of a different future self.

"We are also part of the audience."
Group Material[2]

Carl Oglesby of Students for a Democratic Society,
writing after the October 1967 anti-war mobilization at
the Pentagon, tried to come to terms with the shift
this massive demonstration had mandated; from peaceful
protest to direct confrontation and resistance. He said,
"If I am correct in assuming that men resist danger

and want freedom from all servitudes, then it follows
that rebellion does not take place until it is compulsory.
The rebel is someone who is no longer free to choose
even his own docile servitude." From the revolutionary
as a figure of refusal came Group Material's many
social negations, made multiple and situation-specific
through collaboration with political movements.

46

We said "no" to the false neutrality of the museum
that forbade the social context of relations between our
imaginations, "no" to the reduction of other public
domains to corporatist management and blind consump-
tion. We said "no" to the sequestering of art as outside
the purview of audiences and artists, we said "no" to the
disappearance of subaltern cultures under imperialism,
and we said "no" to the supposed inevitable death
of our friends to AIDS. Our set of refusals were shared
with each other and with the many other individuals and
groupings responding to social inequity at that time.
We recognized that the politics of any group is made real
in collecting seemingly unrelated refusals, showing how
group action can generate new life into an individual—
say anti-war sentiments coming to the teacher from
the loss of her students to the draft, or the collection of
a painter's work by an embassy in a CIA-overturned
republic. Any singular moment of individual self-concep-
tion, of assumptions of the "ethical and reasonable"
can be inspired and rethought through the demands of
collective rebellion and its resonance. When an individual
is moved outside of their normal setting by the effects
of movements for social change, their political function
changes; their consciousness changes. And likewise,
when a participant's political sense in the world
is transformed they are, in turn, displaced from their
accepted senses.

Similarly, the exhibitions and public projects
that Group Material produced were a displacement of
the art object onto unexpected fields of experiences.
By organizing art installations based on political urgency,

inquiry and contradiction, reasonable expectations
for art were upset. Abstract paintings occupied space
defined by popular insurgency, children's drawings hung
alongside electoral advertisements next to paintings
of heads of state, Dr. Seuss books were placed nearby
Joseph Beuys blackboards, institutional critique was
overtaken by "easy-listening" versions of revolutionary
60s ballads, and so on. Such an inflection, of the meaning
of the one onto the connotations of the many, began
with dislocating the historical notion of the supposedly
autonomous art object onto a politically activated theme.
But in addition, the juxtaposition of artworks with
everyday market commodities and publicity design
evoked the possibility of revelation in the undoing
of what already exists. A revolution can even transform
the advertisements in the daily paper, the food in
the kitchen cabinet, and the tools of the workplace.
In a related way, Group Material's transformation of
presidential statements into bus adverts, snapshots into
billboards, subway cars into a gallery spaces, and then
the museum gallery itself into a town meeting, were all
the refusals of established frameworks for the organization
of art, refusals of the limited imaginings of what artists
and viewers could be.

As Group Material's work matured, it became in-
creasingly clear that a form had to be invented through
the visualization of democratic process. How else
could an authentic response to the imposed disaster
of contemporary life be constructed? In the street
and the symposia, forms of response are often beautiful
and collectively diverse declarations of justice. They can

have all the qualities of improvisation, comparison, proportion, absence, suggestion, and substitution. In many ways the practices that Group Material developed were purposively under-theorized, mandated instead by the exigency and belief in life over death. We found these formations in the progressive movements around us, from Central American independence movements facing American-sponsored genocide to the activist response to official indifference to the AIDS epidemic. Our forms of exhibition and public practice reflected the need to invent a dynamic situation, a designed moment of reflection that could include discussion and present dissent. If such an apparatus of artistic presentation emerges

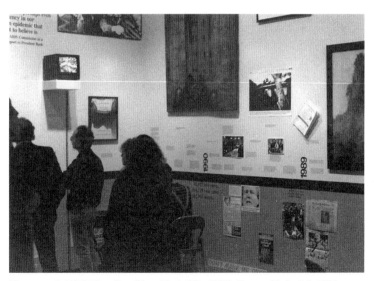

Viewers of *AIDS Timeline* (New York City 1991), Group Material, 1991.

from the framework of political assembly, then the installation of art could begin to look and perhaps even act, like a forum. In calling the exhibition a "forum" we were excavating all its meanings: roundtable, caucus, public assembly, parliament, open framework, anarchic exchange, and more. Making the artwork comparable to the apparatus of democracy did have an actual political effect, acting as a ground for meetings, associations, transformations of artistic context and real probabilities for the constituents of those represented by and attending the work. Especially important here in the collected presentation of this book was Group Material's proposal of democracy as a genesis of aesthetic invention, our presentation of social relations that could be realized by a group of people in an empty room.

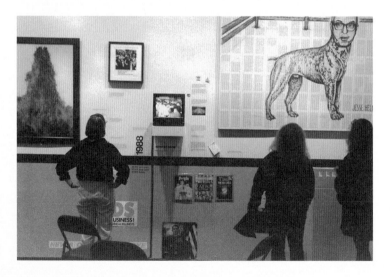

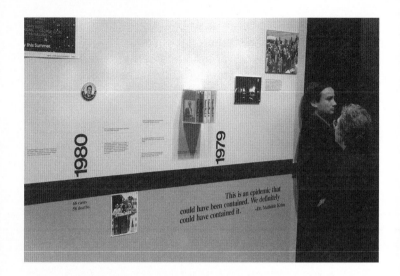

Group Material's methodology of cultural displacement
was anchored in a strong yet abstract image of the
process of political work. This image of democracy as
a void means that public assembly is visually positioned
as a struggle that never ends. It is a template of "forum"
that rejects puerile liberal pluralism and replaces it
with a radical abstraction—the assignment of discussion's
contingency into a shape that is always irregular and
fluctuating.

Art presented as a changeable social forum,
as dialogue, presents a context where not just images but
political will itself can be personified, as a collection of
positions and volitions of different people. Encountering
this art is equivalent to the experience of viewing
a landscape painting where we take the artist's body

51

position, looking across this or that valley toward this or that town square. It becomes unconsciously clear in an experience of a work of art, even in the renaissance convention of occupying the eyeballs of another—that we are in an encounter with someone unknown. Such a formal and physical presence is difficult to discuss rationally because the sense of the point of view of another person is so much more than the strict diagramming of corporeal perspective, the agreement or disagreement with a position. But what can be understood easily is the simple fact that we accept artwork as a form of divergent, even oppositional presentation of another's opinion and idea.

Occupying the sight of a person previously unknown is often a shock. Sometimes even felt like an apparition, it is strangely both erotic and historical, evoking the effect of a long line of encounters that verge on mystical exegesis. Given the ideological hailing of modern institutional life (the way in which we become subjects to institutions outside of any conscious contract), the degree to which artworks can present undiscovered organizations of ourselves is even more surprising. But for Group Material our displaced groupings of visual culture were concrete figurations suggesting that when art insists on new narrations of the self, however mysterious, a process can happen in public. We designed this process to be a complex dialogue: with others through affiliation and love, and through others in the political act of showing the unknown, the repressed or yet to be seen. This process created art turned to ideas of what could be desired rather than existing manifestations,

art that could be the matrix for real solutions, and the
suggestion that art's abstract proposals can actually
figure real techniques of liberation. To defend the notion
of artwork as an encounter with a person and then
to display this encounter in the context of new politics
was Group Material's contradictory innovation,
the design of a place where the self expands by rupturing
in relationship to others.

"Why sometimes do images begin to tremble?"
Chris Marker[3]

In rereading the documents reproduced in this book,
it became clear to me that the kind of work produced
by Group Material simply had to be made—it happened,
like the social activism it followed, out of desperation.
Group Material thought then—and it was not unusual
to have such ideas—that one could create meaning
outside of the privatizing influence of corporate culture
by re-organizing the actual experience of culture
independently. The art projects we developed resembled
the forms of the political vanguard by reflecting the
modern notion that individuals have a right to bind them-
selves together to produce a context that might retain
work and happiness. It is against the 1980s emergence of
a right wing culture of physical control and spectacular-
ized consistency that this generation of artworks
and collective action needed to be rethought. The false
stability of religious fundamentalism, the mediagenic
degradation of culture into profit, the relentless never-

53

returning value of our labor, a historical amnesia that disintegrates capacities to read or even to speak to each other directly—these are all vicissitudes of 80s economic and political regression and they still weigh upon us as an anti-culture of mutual repression. Today this repression seems no longer exclusively produced through the barrel of a gun, replaced by a repression designed through images.

Group Material saw that politics happens at the site of representation itself; not just where information is transferred, but rather at the place we recognize ourselves; where we have the sense that we are ourselves and feel a stability that is hailed and recognized by others. A radical representational moment may be collective but it also suggests that we can give ourselves over to a new vision through feeling, experiences linked to contemplation and epiphany. In this way no public description of another, in frame or in detail, can be presented as neutral. So when Group Material asked, "How is culture made and who is it for?" we were asking for something greater than simply a larger piece of the art world's real estate. We were asking that the relationships change between those who depict the world and those who consume it, and sought to demonstrate that the context for this change would contest more than just the museum: it could suggest the questioning of all public life. In making exhibitions and public projects that sought to transform the instrumentality of representational politics, to invoke questions about democracy itself, Group Material presented a belief that art directly builds who we are—it engenders us. This was an insistence

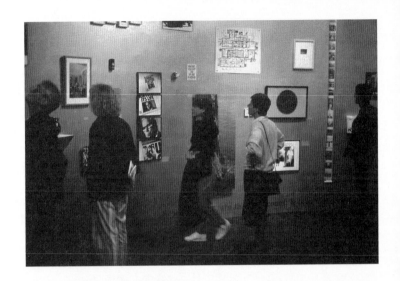

Viewers of *The Castle*, Group Material, 1987.

that the representations found in art give rise to our sense of self and in the end encompass us as subjects. Accordingly we believed that the existing management of art, and of culture in general through the market, enforces a complex system of limiting notions of what makes "us" us or "me" me, what normalizes and enacts the contours of fixed identity. The definitions of gender, race and power were, and still are, dependent on a visual system— images that make possible the recognition or misrecognition of ourselves, between ourselves.

The museum—like the city and the government that creates us within its sphere—is always already in ruins. The anxiety of the proximity to power that art, and art's management implies, is therefore always part of art's production. The historical dynamism of the museum carries within it all the battles fought over the public domain since its modern inception. For Group Material the market-dominated context for culture in the 80s and its consolidation in the museum were presented to artists unfairly, as universalizing opportunities steeped in false neutrality. The white walls that Group Material re-painted red critically reacted to institutions, establishing that they, not artists or audiences, were the producers of meaning. The prevailing notions of aesthetic pluralism at that time, the promotional leveling of all artistic forms onto consumption, the blandly humanist notions of equivalence in scholarship and public record—all partook in the deeply ideological construction of democracy as a kind of blanketing agreement, a blind consensus. If it is true that capitalism is the most creative form of production the earth has ever known, its reservoir of

manufactured agreement strangely needed formal and physical protection.

And it still does. The threat felt by the status quo from art is a real threat. The moment of social unrest of the 60s, like the collectively designed exhibition, shows that you are closer to the ideas of others than you think. Such proximity can be frightening because it returns histories previously severed from experience and opens them up to interpretation. This is perhaps why the experience of an art that can concurrently untangle, remake and re-tangle the ideas we have of ourselves is not easy to produce. The struggle to communicate even amongst those invested in a common project seems at times insurmountable. Presented in this chronicle is the fact that Group Material created work always in struggle with itself, with members often in debate and contention, producing in the end an artwork that manifested this conflict. As part of the audience it seems only logical that our disagreement with the world would inspire dissent among ourselves. That the work is still here represents the strength, its true protest, the working together of ideas and desires that are in friction. If there is an emotional equivalency to the idea of creative dissensus, then it can be found in the resolute presentation of dialogue in Group Material's process and installations. The most compelling memories I have had of the work we did in forming exhibitions are our arguments about them. There was not one artistic product created by us that did not come from discussion, opposition and disagreement. Today, after many artists and many decades of aesthetic experimentation,

dissensus can finally be proffered as the theoretical basis for imagining social action — it is an emotional invention of great beauty.

Group Material's self-assignment was to locate the dissensual feelings associated with activism, its emotional reverberations and actual evocations, into a realizable model or design. It meant we had to try to invent visual solutions that would be able to question themselves. By insisting that the presentation of art could approach the experience of dialogue and dissent, we showed that when art addresses us as subjects in conversation, we can experience art as an array of personified encounters. We created a site wherein multiple and conflicting forms and histories could cross over and weave themselves through one another, mutating into paradoxical and unexpected notions of how we might define ourselves as humans. When artworks are engendered as persons in dialogue, the experience of art can make a rebellion.

1   Colin MacCabe, *Godard: Images, Sounds, Politics* (Bloomington: Indiana University Press, 1980), 153.
2   Doug Ashford quoted in "Dialectical Group Materialism—An Interview by Jim Drobnick" in *Parachute*, Oct/Nov/Dec, 1989, 31.
3   Chris Marker, "Le Fond de l'air est rouge (A Grin Without a Cat)," 1988.

# Finding Cythera:
# Disobedient Art, and
# New Publics

In the spring of 2004, Anne Pasternak, president and artistic director of Creative Time, asked me to help refresh a practice she had begun some years before: the production of discursive forums between artists and thinkers on public practice. Almost a year later, thirty-seven artists and organizers responded to our invitation and attended three dinner conversations moderated by myself. The call to confront the failures of art and art agencies in actually producing radical cultural divergence was embraced by many participants. Contributors seemed to share the project's willingness to look beyond the reasonableness of prior experiences of public art and activism—and to begin to model public experiences that could refuse to reproduce false progress. The edited transcripts of these discussions were collected, with detailed annotations and appendixes, into the book entitled, *Who Cares*. In its introductory essay reproduced here, I use the potentialities of mythological identification depicted in Watteau's painting as a template for perverting accepted understandings of public life—whether those of the urban entrepreneur or the reductive social ideologue.

"The idea is that the activity we undertake with each other, in a kind of agonistic performance in which what we become depends on the perspectives and inter-actions of others, brings into being the space of our world, which is then the background against which we understand ourselves and our belonging. I find this a compelling account because it stresses historical activity and human creativity, but without falling into a naive view of individual agency or intentionality. The world made in public action is not an intended or designed world, but one disclosed in practice. It is a background for self-understanding, and therefore something not purely individual. It is also immanent to history and practice, unlike ideas of community or identity, which tend to be naturalized as stable or originary." Michael Warner, *Queer World Making*[1]

My experiences with the capacity of art to re-create public life through performance and play has been made understandable through a history of collaborations: in classrooms, in the museum, in the street, and through-out the social contexts occurring between them. The conflict between these spaces, and the habits and events that inform them, is the matter that inspired the planning for the conversations that follow. As a con-sultant on the organization and documentation of *Who Cares*, I was often reminded that the collaborative work artists do to effect public life is intimately linked to the performance and play of conversation—those that we have between ourselves and our audiences. The possibility of transforming a politically silent art

system into a collection of discursive and engaged forums has occupied a signal community of artists for many years, as part of a larger desire to obtain and defend a truly public context for culture in this country— a struggle that is far from over.

In helping to plan the *Who Cares* project, I looked for political proposals in an unexpected place: easel painting. Historically, painted pictures have modeled a world decolonized from the constraints of official power and subjective pose by visualizing the social relations that can only be built or arranged in a purely invented place. This idea of a painted picture as a performed invention is perhaps as old as pictures themselves. And the dialogic performance of a picture—the collective speculation in the space we hold between ourselves in the viewing of art, the way an image hanging on a museum wall defines a public forum in front of itself— is also very old, reaching back to the Enlightenment concepts of the public realm, the parliamentary room, and the politics of virtue. Before stumbling back onto the moments of collective speculation that painting once instigated (and still does), I began with the psycho-geographic drift of the 60s and I worked back from that era of radical public art practices through other precedents. I found painting to be one possible origin of our ability to see contemporary dialogue as an exercise, simultaneously aesthetic *and* political.

In the beginning of the eighteenth century, many paintings were made based on the liberating effects nature was assumed to have upon social conversation. There were two works from this period in particular

that drew my attention: *The Pilgrimage to Cythera* and *The Embarkation for Cythera*, both painted by Antoine Watteau between 1717 and 1719.[2] Each depicts lovers in transit, interrupting an ongoing public communion that they are having with each other and the Arcadian setting they traverse I looked to these images for a way to imagine a resolution to the anxiety I felt (and still feel) when confronted with the conflation of the sensual and political demands we place upon social dialogue: on one hand, we look to conversation for pleasure; on the other, we have trouble considering it apart from its ethical functions, its foregrounded role as the basis of a free society. But these paintings represent more than the traditional salon parlay.

Although painfully elitist in many ways, these pictures offer the symbolic possibility of conversation leading to collective excursion, a departure from what is expected into an improvised performance. For me, this is an extremely contemporary proposal. Watteau insists that the tension between the drive toward pleasure and the social necessity of politics are intricately linked in the performance of every cultural exchange. When we dance, we pose and reform. When we converse, we challenge and accept. Paintings of social escape and interaction ask that a viewer accept happiness and knowledge as two dialectically interdependent notions.

Cythera is the island where Venus was born from the collision of the son-castrated genitals of Uranus with the foam of the sea. For Watteau and his audience, it is understood as dramatically metaphoric, a figurative place inspiring the reassignment of desire and morality

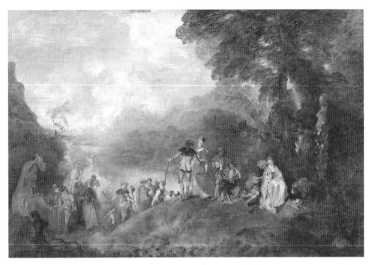

Jean-Antoine Watteau, *A Pilgrimage to Cythera*, 1717.
Musée du Louvre, Paris.

according to the social hopes of the libertine's imagina-
tion. The social conversation that generated the period's
approach to sexuality was imperative in discussing
this transformation, especially in its insistence that
we ignore all existing aesthetic and political expectations
in the alliance with passion. What is key here, though,
is that it was the possibility of conversation as a subjec-
tive experiment that was the bridge to this realization,
both for love to develop and for knowledge to be
produced. Watteau's scenes represent the ambiguity of
conversation as a form of free association—talk as per-
formance, conversational address as drag, and discourse
as a form of call-and-response—this in turn predicts

and parallels the parliamentary social entreaty, the parley described in Enlightenment philosophy as a potential basis for emancipation. So these paintings of lovers on a trip are more than signposts to pleasure—they are guides to the challenges faced by public expression. Viewing them, one can imagine how social space must be emptied if it is to be designed to accept the discourse of emancipation. Such an "empty" space—capable of representing dissent and difference—still stands as a metaphor for democracy.

Now that the three conversations of *Who Cares* have taken place, I conjure Cythera again as a reminder of how this project began as a series of meetings separated from the producing and commissioning work of Creative Time, informal spaces that could be somehow emptied of purpose and utility. We wanted participants to be able to speak of the public culture that seemed impossible to speculate on and realign. The poverty of responsive, socially active visual culture in New York City was the genesis of Creative Time's proposal and of my involvement. My contribution began as a reflection on artists' insistence on the *dialogic* nature of art, for art's potential to create contexts in which groups of people could re-design their relations to each other, to fairness, and to happiness. I wanted these conversations to reflect the potential of art to call for non-normative models of happiness, models that resist those profitable pleasures engineered by the increasingly consolidated ownership of culture. Such calls are a consistent component of all countercultural practices: if we want our happiness,

we have to design our own forms of interaction, both physical and social.

My insistence on the viability of counterculture as an organizing theme for these meetings was not particularly unique.[3] There have been calls for reprogramming culture and intellectual life in America for more than thirty years now—from the search for alternatives in museums, to free presses; from war resister leagues to commercial-free journalism; from community schools to food co-ops and more. Such calls are now increasing with the growing management of intellectual expression, which takes form in things like the anti-abortion and pro-oil lockdown on scientific research, the self-censorship of journalists, and the ideological invasion of the academy by censorial "watch groups." Art and its attending institutions have cyclically responded to such crises, but recent cultural repression dominated by the explicitly dark conflation of a planned deprivation economy and the social terror imposed by our government's relentless sponsorship of war, poses a particularly immense social field of repression.

For many involved in cultural organization and discourse today, the progressive role for public art sponsorship, presentation, and promotion depends on representing often subaltern histories of radical public uses for art—possibilities that are difficult to discern in today's market frenzy. Many institutions of art and criticism seem to have selective amnesia concerning work that questioned the ownership of our economies of production, the use or development of cities, and the social function of urban institutions. The paucity of

historical thinking in America is an epidemic any teacher can attest to, but it is curious that the capacity to imagine countercultural discourse has diminished even in New York—a city that has inspired so many re-inventions of self and space, and that has seen definitions of pleasure change and adapt to the imaginations of its residents.

Accordingly, even though the participants of *Who Cares* were asked to describe *new* possibilities for critical visual forms, they spent a lot of their conversation describing what kind of visual dialogical tactics worked in the *past*. Artists do this. We list and compare, trying to recognize new examples and hoping to mis-recognize official taxonomies of received ideas. Indeed, my inclusion of Watteau on a list of progressive public art practices— which for me includes James Brown, The Guerilla Art Action Group, Archigram, and Louise Lawler—speaks already to this process. One purpose of the *Who Cares* meetings was to compare these lists, to set a new agenda for the possibilities of resistant art rolling into the future, and to collectively build, through conversation, a foundation of examples that could be used by future practitioners. Suitably, this publication includes a partial enumeration of references, definitions, and inspirational examples that can be read alongside the testimony and inquiry of the three conversations. In other words, as these discussions evolved as performance, the possibilities of the past could be set up for consideration alongside speculation for the future.

The following conversations diverted in another important way from planning expectations. Although

I wrote in my letters to the participants that I wanted the evenings to be "working meetings," a central reverberating image for the whole project was not "work" at all. It was *play* — or at least ludic interaction as a potential form of research. This is something embodied by Watteau's pictures and presented or theorized by other Enlightenment projects, from the French socialist Charles Fourier's utopia of "conviviality" to the "play instinct" identified by German poet, philosopher and dramatist Friedrich Schiller. Play and experiment is exemplified in many of the practices and problems discussed in these transcripts. For the critical efforts that we have labeled countercultural, much that is important about play begins with conversation. Equally important though, is an understanding that the emancipatory moment for new communities demands privacy.

It is, after all, hard to play in public. Private play, claiming freedom from interference to generate independent discourse, is crucial to developing countercultures. Imagination looks to be separated from the constraints of late capital's mediagenic complicity and the false ideals of "participation" that our neo-liberalism has perfected. Of increasing importance to many activists and artists alike is the achievement of some kind of separation from garish examples of marketing as "interaction;" the introduction of a disobedient voice into the consolidation of media ownership into tinier and tinier spheres of self-reflection; and a rejection of the literal selling of electoral outcomes through advertising onslaughts.

Although seemingly in contradiction with our topic of the possibilities for public art, the consideration of

social subjects is incomplete without an understanding of privacy—that is, how communities redesign themselves in opposition to, or in separation from, dominant culture. I would like to include all communities in this definition: from those seeking to escape normative boundaries of desire and sexuality, as well as those clubs, labor unions, consumer cooperatives, user-groups, and civic associations of all kinds who create new languages and subjectivities out of the possibilities that association gives them. Two generations of feminist and queer social practices attest to the critical utility that withdrawn conversation has in building rebellion. In order to raise consciousness we might need to be alone for a while! Importantly, these critical trajectories help us to distinguish between the forms of isolation that are impressed upon us. With financial deprivation and compulsory pleasure regimes being projected from on high, it is important to realize the resistant effect of autonomous programs we can determine and construct for ourselves. More than ever, artists need to be alone to re-think their relation to an industry overwrought with competition and overrun by market promotion.

In a context of increasingly commercialized relations for visual art production, the management of expression has as much to do with implicitly forcing speech as it does to actively squelching it. A repressive apparatus of official censorship not only manages our expressions, it also pressures a population to adopt certain stances and attitudes. It is hard to tell which is worse: being told that certain images or ideas are offensive to the majority

by a militarized state, or being told that to be accepted we must speak a certain way or say a certain thing, as illustrated by recent official demands that we speak English, have a flag on our car, or get married in a chapel. This insidious form of public management through compulsive affirmation has a direct effect on artistic practice. As artists we are barraged by signals in our industry to be positive, encourage participation, and "keep the faith."

Private dialogue as experience can be understood as an independent aesthetic product in the re-establishment of privacy and friendship.[4] For my purposes here, it was critical to accept early on that the *Who Cares* conversations would be justified in themselves, separate from any use they might have in the future; and separate, certainly, even from their potential publication. The discussions were justified simply in the bringing together of individuals in a temporary space of mutuality. The private, separated time for conversation is a potential space for multiform inclusion. Through the experience of juxtaposition and comparison, the diverse and competing lists of points and ideas that arise in conversation stand in for a larger exercise in democracy. Conversational comparison can be seen as a map or a plan, a proposal or a picture. Abstract and romantic in an art historical sense, this visual form of inclusiveness as evinced in Watteau is part and parcel of post-enlightenment aesthetics— from Schiller's suspension of the self and his notion of the world in play, to the affect of a subjectivity that is always in a state of becoming, what the painter Jan Besemer refers to as the "stammer of inclusion."[5]

Hans Haacke reminded us in the 1970s that "art is social grease."[6] As most of us know, going public is always risky. To the managers of public spaces today, relational practices that are based upon the open-ended inclusion of audiences in art world celebrations fit frighteningly well into the logic of uneven social development. An art festival, a public art program, or an art center might be more persuasive and less expensive than a police officer's baton. Just as meta-advertising designers incorporate leftist progressive political trajectories to sell sweaters and suits, public art projects can legitimate the smooth, uninterrupted authority of urban renewal and its attending erasure of cultural difference. Cities now find distinction through art and its industry's symbolic capital. As Miwon Kwon has clearly argued, public art's currency comes in giving cities the identity they have lost to redevelopment while they continue to redevelop.[7] The expected intervention of what came to be called "new genre public art" under the official guise of community-based art production was arranged neatly during the 1990s to re-enforce the idea of city as a paradigm of controlled and developed appetites. Even this publication, and the process it seeks to engender, risks a dilemma: the linkage of public practices to the policies of development of a new "cultural class," a demographic addicted to an unending consumption of newness and promotion. This narrative for art is now coupled to the design of experiences that form a symbolic foundation of capitalist accumulation.

The difficulty of planning democratic contexts that will effect a replacement of existing discourses is not

to be underestimated. Although the discussions for *Who Cares* were planned to make room for the failures that privacy allows, our exchanges often reflected work and careers. The implicit and invisible weight of institutions in the sponsoring and organizing of supposedly speculative critical forums needs to be better understood. How are these conversations going to be used, and by whom? Artists' collaborative agendas, even if designed in private, can be appropriated into the boutique factory that has become the American city. For many (and specifically, for some who were invited to these talks), any engagement in conversation without the concrete commitment to art sponsorship that allows us to disassociate our work from this spectacle is like polishing silverware in a burning house.

From talk to love to revolt. Since the beginnings of modernity, we have seen the notion of happiness linked to emancipation. Again critical conversations are asking what kind of freedom particular public practices might predict. If we are free, then what are we free to do? In a way, this is one of the first questions informing the modern disruption of private concerns and public occupation. The members of Watteau's libertine courts are in a sense "free" to pursue their own subjective transformation in the separated context of theatrical play. In the associative roles they perform, in what amounts to a hybrid private-collective escape, we can find new subjectivities and experimental forms of political understanding. Michael Warner has argued beautifully that the shared performance of private understandings can change broader conceptions of democracy.[8]

73

1   The epigraph to this essay is drawn from Annamarie Jagose, "Queer World Making: Annamarie Jagose interviews Michael Warner," *Genders* 31, 2000. Accessed June 11, 2006. http://www.genders.org/g31/g31_jagose.html#n11.

2   For a complete discussion see Mary Vidal, *Watteau's Painted Conversations: Art, Literature, and Talk in Seventeenth and Eighteenth-Century France* (New Haven: Yale University Press, 1992).

3   See the full text of my letters to the *Who Cares* participants on page 138. Melanie Franklin Cohn, ed., *Who Cares* (Creative Time: New York, 2006), 14–20.

4   See my essay "The Boy in the Park, or The Miniature and the Model" in Wolfgang Tillmans, ed. *Jochen Klein* (Cologne: Walther König, 1998), 75–92. The essay examines how the discrete art object is equal to the more "respected" process of institutional critique in terms of proposing re-alignments of political and aesthetic thinking.

5   See John Rajchman, *The Deleuze Connections* (Cambridge: The MIT Press, 2000). I am connected to the possibility of the "stammer of inclusion" as a radical formal method through Jan Besemer's writing on the politics of painting. See Jan Besemer, "Abstraction: Politics and Possibilities." *X-Tra Contemporary Art Quarterly*, Vol. 7, no. 3, 2005.

6   Hans Haacke, e-mail message to author, July 17, 2006, in reference to his work *On Social Grease*, 1975.

7   See Miwon Kwon, *One Place After Another: Site-Specific Art and Locational Identity* (Cambridge: The MIT Press, 2002).

8   I am indebted throughout this essay to Michael Warner's thoughts on performance, politics, and the public sphere in Michael Warner, *Publics and Counter Publics* (New York: Zone Books, 2002).

This essay fictionalizes an imagined meeting between two individuals very close to me who in actuality never met: my mother and my friend Felix Gonzales-Torres. Sifted through stories told to me by both of them, the writing centers on how holding snapshots physically in hand can produce an emotional use of photography, possibly shared by many others before the digitization of imagery gave our memories away to the internet. I wanted this essay to show how the physical re-arrangement and storage of snapshots might create a lived experience of imagery that could serve as a bulwark against an impersonal future produced by power— one that is designed to appear to last forever, but without us. It was written for the first issue of a journal published at Saint Ann's School in Brooklyn, where I taught eleven and twelve-year-olds for many years. The text was produced with the energy of these children in mind and in anticipation of the photo-memories they might produce.

A couple embraces one last time in front of the metal detector, his tears touching the other's lips that press on his cheek. A gray man in a brown sweater looks nervously through a crowd. Another couple taps on a vinyl security barrier for recognition, a little more loudly or a little more fervently than the child entering the gate can comfortably tolerate. Silent hands wave from the airplane windows, their gestures increasingly unclear as they signal to a departure ramp where people's faces are becoming too milky for recognition. Bored laughter echoes from a bar as someone fights to remember the last time he was with someone he really liked. A quiet man who must have just heard some very bad news is barely audibly barking tears. He is stuck at the baggage claim area, where the suitcases are coming out and circling. He too circles the carousal, as his former passengers jostle for a position from which to see their own possessions.

   She always said that she changed as soon as she entered an airport. It was either the need to get from one distant place to the next, or the recognition that her body felt so much older, moving amongst so many others, that caused her to pause on entering these great avenues. Being between places, being on-her-way at such a velocity was exhausting, and within the complex space that modern engineers have designed, completely confusing. Airports seemed, she said, to not only be built in order to contain her privacy, but to simultaneously disallow its effects. She felt protected from the embar-rassment of other peoples' emotional abandon in such a seamless environment. Such intensity of feeling seemed

out of place in edifices designed for the smooth transition
of bodies from one type of containment to the next.
The generic curve of a hallway, the lines of an automatic
faucet in the lavatory; such rationalism always seemed
surprising. Such surprise, she said, seemed strangely
terrifying.

So she tried to be ready. She prepared herself
for infractions, either personal of public, with snapshots
in her closest handbag. An envelope of ten or so pictures
that she could handle in those brief moments of reflection.
She called this envelope a "Power Pack," the name
referring to the portable energy systems often associated
with appliances or toys. But these pictures supplied
an energy that was neither traditional nor expected
because the subjects they depicted, seemingly random,

were never exactly recognizable as photo album fare.
Instead her pictures were of things like pieces of furniture,
or the upturned covers of some pages of an old book;
a Polaroid of a sand covered towel, a bouquet of zinnias.

Neither album nor memorial, the "Power Pack"
was something she first heard about from man on
a plane many years before. Sitting next to each other on a
particularly arduous trip and trapped in the middle seats,
they shared stories of their origins. He showed her
a small enveloped of snapshots, images that gave him,
he said, the energy to make it to the next city. You couldn't
describe the pictures with easy captions. Nevertheless,
they overflowed with meaning. Each picture becoming
closely associated with the other through shuffling
and rearrangement, pushing forward the juxtaposition of

content that color photography provides so wonderfully.
(A blue sky in Florida goes with a blue blanket in
New York.) His pictures impressed upon her the idea
that configurations of memory could be re-arranged and
perhaps even changed. Images and memories could
function like an amorphous list that might allow him or her
for that moment to feel the form of the present as
a malleable and, somehow, caring—a sensitive system
built to the sentimental needs of one day, singularly
different from any other. Ever since that chance meeting
on the plane, she refused to own photo albums;
she preferred instead to watch the images pile up in
various drawers and on all the surfaces of her house.
To her, the modest separation of one picture from another,
ordered by place or time or both, meant the organization

of memory as an oppressive presence: an authority
without transparency. (Something like an airport in fact.)
The permanence of such ordering seemed incongruous
with the charm of returning to people and places that
were already gone. When she lost snapshots in her
boxes or on her shelves, it seemed to make a strangely
consistent sense.

She received a photograph or two from time to time,
occasionally with notes on the back, from the man
she has met on the plane. These joined the others she
was accumulating, now freed from the order of albums,
and together they helped establish a sense of memory
that she could build on, or sometimes even invent.
Her archive became wonderfully unfamiliar, or even
estranging, but more encompassing of its subjects.

In viewing the isolated photos, she felt as if she could see into a luminous disruption that existed just beyond the frame in all of them. The photos she collected were writing different histories for herself, better than any she could self-narrate; histories not excavated from beneath but instead voluntarily drawn from all the spaces around her, from the airports she was growing to love and the whispered conversations therein, to the thoughts arranged in the rooms of her home.

The familiarity of some photos gives great pleasure because they articulate the tension between the idealization of life and the ambivalence towards actually lived experience. They negotiate the struggle between what is wanted and what can be had. In a way all personal photo collections ask a similar question: What wishes

are there that should be preserved? Which *can* be preserved? The scale of the personal will always be so out of proportion to the public that the photo will grow sentimental and dear. Meanwhile, some of the things we are encouraged to make public have been eroded in their power to transform, as a glance to any medium will confirm. By sharing photos of things that are not easily identifiable as part and parcel of a family, a city, or a nation, a kind of forgetting is taking place. Perhaps a social act, this kind of forgetting clears the mind to the possibility of reconciliation and identification with others. Pictures treasured by those telling a story, pictures traded and collected, are used to forget a sterile past invented by others and to make the present more our own.

# A Boy in the Park, or, The Miniature and the Model

In 1998, the artwork of Jochen Klein was collected
by his companion Wolfgang Tillmans and organized for
a posthumous exhibition at Feature Gallery in
New York City. I was asked to write a short piece on
Klein's relationship to Group Material. Klein had joined
our group in 1994 together with Thomas Eggerer.
The two had lived as my neighbours for some time and
shared in the daily experiences of school, friends
and families. The resulting text, which has been reprinted
a few times since, tries to present my enthusiasm
for their re-thinking of pubic space as a dream world for
subjective experimentation and fantasy. If art proposes
new definitions of human life, even the indescribable
forms of intimacy and affection between us might
be presented as possibilities for human identification and
change. This connection between sentimental forms
and political aspiration proposed for me a context for
public art separated from existing programmatic
contexts for social progress. Accordingly, the exhibition
practices of Group Material became visible to me as part
of a larger emotional proposal.

Do you remember the time we saw that young boy in the park, at the English Garden in Munich? He made such an impression on us. We both realized that it would be inappropriate to misrecognize his delicate and reflective features for something else, as representative of something that you said we each wanted in our lives in different ways but couldn't yet have. The way he seemed to shine reminded me then that being overwhelmed with duty can afford a kind of pleasure — like when you work real hard to make a nice house or a nice dinner for others so your own image can shine a bit more in their minds. I thought that I could shine like that in producing things for other people, like that boy, or in achieving something with other people. I guess I felt that day in the park that the boy could have been my friend even without knowing me; or I guess I dreamt right then that we had a life together or at least would be able to work together to make something really great even if it would last for only a short while. Remember how silly we felt projecting onto him, a total stranger, all the idiosyncratic fantasies we held about our private and public lives?

Well, that boy came to mind again for me in thinking about how I've spent years making art with other people, either as critical renderings of museum policy or as interrogations of urban life, in the form of exhibitions or writings. Public discussions on the policy of culture are so hard to compare to the intimate things that we really value. Like those things we want enough to wake up and see placed next to our beds. But these days I feel a need to think of activism in relation to intimacy: a need based on all the things in the newspapers and

Preparatory tracing by Jochen Klein for his painting, *Untitled*, 1997.

from in past, things that approach me when I can't sleep. Anyway, the reason I'm thinking of all this again is because I saw someone just like that boy, or I should say a rendition of someone just like him, in a painting by Jochen Klein. He left a number of paintings behind that are beautiful and important. They're important to me today because they reflect on the dilemma of reconciling my work on public issues with my fascination with intimate pictures. Such a dilemma is complex and worth telling you about, because I think it points to a fundamental fiction in our industry: namely, that the desire to describe a radically sentimental subject and the need

to address institutional hegemony are somehow funda-
mentally incommensurate.

It may seem paradoxical, but I have been noticing
an essential rapport between these paintings and
the work that Jochen produced with Group Material.
Finding affinities between these paintings of quiet figures
in pastoral landscapes and a collective project-based
art practice that appropriated museum galleries and
public spaces may seem a ridiculous task; the two seem
so incomparable in appearance. What do images of
men with baby tigers, sad geese, ballerinas, and boys
lying around with sleepy rabbits have to do with institu-
tional critique? They don't resonate with the converting
advertising space, or exposing museum authority,
or reinventing collecting impulses and rigid archives,
but instead with the actual working process that comes
forth in collaboration. I think that Jochen's paintings
reinforce the idea of an artwork helping someone imagine
themselves as socially perfectible. More specifically,
they remind me of the concern for a particular collective
voice that Jochen brought when, together with his friend
and collaborator Thomas Eggerer, he joined Julie Ault
and I to work on the last projects of Group Material.
His effort to represent the possibility that shared pleasure
has in transforming subjects was a great influence on us,
and in many ways, this concern underlines a structural
imperative of the work we did together. You see, our
inclusive and collective exhibition practice, which posi-
tions artists as producers of social and not just cultural
meaning, came out of a process that depended on friend-
ship, rapport, and affection.

For me, Group Material in all its manifestations since 1983 had a profound sense of origin in the excitement that accompanies identifying friendship with production. It seems that maybe the most transgressive possibility for an individual faced with the tyranny of confession and trauma, may be simply to have a friendship. Even with all the disappointments that arise with intimacy and affection, as a projection, friendship still seems an effective way to think about the work that Group Material did together. Our discussions on the choice of themes, sites, objects and artifacts and in planning models of address and structures of display were fundamentally about projecting ideas we had of *ourselves*, which were dialogic and inclusive, onto art institutions, which appeared myopic and falsely neutral. The possibilities for art were made real in the relationship between collaborators first, and then exported in a sense, in the form of a model. The juxtaposition of artworks and artifacts on the wall of the museum represented, at least in part, our own dialogue and discussion. Our process and our product were inexorably linked to the idea that collaborative attention can open institutional dialogues to the specific representations of marginal and difficult ideas. Each exhibition and public project was a model then, a "miniaturized" presentation of a social possibility that was different from the gargantuan forms of persuasion and regulation that surround us; a modeled representation of something we experienced in working together.

Jochen's paintings seem to provide a similar proposal in that subjective change, like social change,

is dependent on physical models, i.e. artworks. I think people these days often see the idea of modeling radical subjectivity as complicit with corporate culture's narrow fantasy and a good deal of the time they are correct. But the figure-in-the-landscape images that Jochen produced are subjectively oriented extensions of social inquiry because they reflect the way that all imaginings of different futures are also ideal projections of the self: models of what we *could* be. Like the miniaturized projection of an exhibition as a model for changing culture, Jochen's paintings show figures that are miniaturized in relation to the gigantic and perfect natural sites that they occupy. Models are always smaller than the real space they make proposals to. They have to be in order to project in miniature a picture of a tentative, possible future that many audiences could see as a usable, experimental experience. Or better, in showing us models of people that can perform like these tiny fairies or nymphs, Jochen shows figures from the past, from childhood or fantasy, that are presented as an alternative present that is not threatening. The boy in the grass is representative of an ideal subject, what we would want today if we could use our memory and history in some more effective way.

These days there is much heroic and strident discussion from all points in the ideological spectrum that reduces marginal identity to a public distortion of the body. I'm thinking of things from Jerry Springer and body-building to anti-abortion posters and Presidential penises. A culture of spectacularized perversity exposes the body by turning it inside out into a carnivalesque display.

I can acknowledge the way that the free zone of
a carnival turns the world upside down in order to posit
new and radical roles for its subjects. These are what
Susan Stewart calls, "bodies in the act of becoming,"
but as useful as they may be in countering the spectacle
of submission to violence with the spectacle of opposi-
tion, I am filled with doubt about their presence.
The body torn and re-made, presented resistantly and
grotesquely to the view of a political majority, does indeed
provide a chance for subjects to imagine themselves
as different, as freaks, outside of and liberated from
the oppressive norm. But in replicating the forms of the
spectacle of public distortion without attending to
its context, such grotesque bodies seem less and less
able to act radically.

Jochen's project in these paintings appears to me
to be very different. The body that he is proposing
is more perfect, both more distanced and domesticated
at the same time. Unapproachable but familiar objects,
the figures that inhabit these paintings are bodies frozen
in an ideal time. They are shiny to the extent that they
can reflect our will and desire in the abstract. They are
colorful enough to allow us to place them in relation
to some public fantasy that we have entertained at some
time, but not enough to become or replace that fantasy.
This is certainly a type of objectification, but one that
is based on experience and imagination not trauma.
It proposes possibilities that are intimately interwoven
with ideal figures of everyday life and the paths these
figures take through and against our lives. The colors and
surface of these pictures, like the skin of the ballerina

93

in one of them, reflects a story that we can only fully identify with as a kind of frightening, delicate, and reflective perfection. This skin of a miniature always appears true because like a model, it exists in the form of an abstract proposal, without contingency and purely representative of something we can project *onto* but never *into*. In a constructed world where the skin is so reflective, this mad wounded culture we actually live in cannot reach us. These little figures are models of a different subjective possibility for a viewer, one based on memory and fiction at the same time, a model that we can play into, wherein we can imagine ourselves as different people.

If artists have a dilemma between exposing our ideal figurations as grotesque, all orifices and turned inside out in grand display, and of miniaturizing ourselves into a perfect model of a self or selves, then Jochen and Group Material probably fall into the latter position. Together we wanted to make models of a comparative cultural forum that would act as a rendition of perfection that was ideal in the sense that it was already past the form of failure. Jochen's voice in Group Material brought an insistence on subject positions that would allow and even encourage the radical objectification of other people. He said to me once that he wanted a public monument to remind him of walking into a stranger who he could really fall for. Whether this stranger is an ideal rendition of the self or an *other*, it hardly seems to matter. In both cases it is undifferentiated alien, someone that either you or I could mistakenly identify as a friend, a companion, a collaborator. This brings me

back to the boy we saw in the English garden. You see, that boy was an emblem of Group Material's process, Jochen's figure, and our young ideas in the park that day— all echoing how great it can be to make fantastical investments onto other people. In imagining ourselves as the perfect companion for a stranger, we were and still are making models of an alternative future. Such sentiment I think, is a guide to the radical potential of intimacy. And a guide to our memory of it.

This text was presented as a slide performance for a series of discussions organized by Christian Philipp Müller in Hamburg in conjunction with his 1997 project *Public Art is Everywhere*. Christian's early understanding of how artistic investment in the public sphere could be co-opted for the purposes of economic exploitation was both prescient and articulate. During this period, Group Material had also seen its earlier ideas about expanding public understanding of art and democracy appropriated into the larger framework of official cultural sponsorship and the privatization of the public sphere. My text was an attempt to extend our disappointment with what was then called "community-based art practices" into a broader understanding of the dual character of progressive public cultural agencies, whose democratic intentions often had reductive implications. In such a context, art that tried to name experiences outside normative narratives of "progress" was either censored or stylized into neutralized contexts of display. This essay testifies to the early stages of a call for new definitions of "social practice" that artists then began to demand: art that publicly produces both irrationality and empathy.

"Many cultural institutions will lose their credibility if they don't develop community-based initiatives. Art may have appeared very exclusive but it is now a way for organizations to appear to have an interest—a stake in representing community concerns. As government funding becomes scarce they have to look for support in other areas. So, suddenly these groups realized they need to develop community constituencies."
Cultural fundraiser, Pittsburgh

"I want to know why all of a sudden there is all this interest in the community. Why now, at this particular time, when you were not interest in us before.
What are your motives? What are your hidden agendas? Why is there this trend?" Resident, Pittsburgh

As others have pointed out, it seems that the whole notion of site-specificity has been overburdened with the changing characteristics of nomadic capital. Since there is no "there" there in a city that we as subjects can map or own, various forms of power have initiated urban reform and renewal to "re-humanize" the city. The failure of such renewal efforts to do much more than further separate the wealthy from the rest of the population has been well documented. Also on the record is the intimate involvement of supposedly progressive architects and urban designers in this process. Efforts of public art agencies have inherited this narrative of urban reform and helped to accelerate it.

Urban renewal is by definition relentlessly utopian. In theory, Governmental officials and executive officers

imagine the needs of the citizen but in practice they intensify their towering image of a city fortified against the majority of its residents. Their master plan needs to be both a singular representative of the permanence of corporate presence and subject to the wandering manifestations of consumption and the overwhelming sensuality of huge urban infrastructures. Planners instinctively understand our need to feel the anxiety of scale when we shop.

The proposed perfection of many downtowns continues unabated, while the satellite neighborhoods deteriorate into a global phenomenon now known in the U.S. as "third worldism." As our cities are increasingly divided according to the dependable categories of wealth and race, the gigantic paradises of Nike Town,

Warner Bros. Store and Disney fill urban centers with "pleasure." These spaces are taken up as theme parks, representing a displaced notion of how we actually might live together. The meeting ground for all citizens is where they can meet as shoppers. Meanwhile, the gap between the rich and the poor has been growing so steadily in America since the end of the 60s that nearly a quarter of our population now lives below traditional understandings of a poverty line. The public fantasy of a downtown scripted by the libidinal drives of consumption is more and more the solution to the urban crisis.

But the rhetoric of urban renewal is spoken with great sincerity by those that work within its logic, a rhetoric that is often falsely inclusive and liberal. We consistently hear from city planners how everyone

should have a voice, be empowered to move freely through both space and class, and be able to exercise fluid notions of democracy. It is not a mistake that renewal agencies recognize the management of space as a force in reorganizing social position and place. Artists and the agencies organized around them try to reinforce this refrain but often remain separated from actual power and therefore from ideas of consequence and responsibility.

In 1983 the artist collective Group Material produced a self-initiated public art project called *DA ZI BAOS*. This is a Chinese phrase meaning large character posters, from a movement occurring the end of the Cultural Revolution in which signs were allowed to be posted on a certain wall in Beijing. In their original context these

statements took on the form of a public dialogue that eventually led to actual reformation of policy decisions by the state. What we did in New York in 1983 was to interview people informally on the street, or formally in offices and workplaces, to establish a series of texts that would describe the relationships between a person and the topic or subject we were addressing. The finished product was a series of quotations that were wheat-pasted onto the side of an abandoned department store. The quotations compared opinions on pressing governmental policy decisions: from prison reform to military intervention in Central America. Subsequently, Group Material's *DAZIBAOS* work has been done in many ways in different contexts over the years. But the principle has remained pretty consistent for Group Material and I think it is applicable to the nascent disaster of tyrannical community descriptions that we now inherit in much of the discourse around public art.

Resisting the idea of a survey or a poll, the piece was more like a manifesto authored by us in which a model of how to reconfigure social space can be presented within the public sphere. Although the concerns of self-identified communities were represented through the statements of individuals, the actual meaning of *DAZIBAOS* was more than the set of texts on the walls. We were making a model of a social conversation in a public place rather than representing any of the particular voices that were actually in the work. Such a project wasn't about "empowering" or "enabling" any of the participants but instead was an effort to picture of the process of democracy itself—as something

essentially empty until filled with the struggle of com-
peting voices and the agendas of individuals and alliances.
We seemed to be saying that such a picture depended
somewhat on rethinking space as neither neutral nor
inconsequential.

Our interviews in streets, homes and offices had
no preordained plan or limitations. *DAZIBAOS* could
have included points of political identification or political
will. In particular, it had the characteristic of monumental-
izing a random or wandering subject. Our viewer
could assign her or himself to a plurality of represented
identifications and political positions. One of the remark-
ably consistent features I remember from the early days
of putting together art shows and other forms of
cultural activism was the frightening misuse of pronouns

by folks occupied with organizing others. It feels
so predictable now to observe how often the word "we"
really stands for "me," or an even more confusing
use of the word "everybody" instead of "me." As a teacher
once said, there is a "presumptive and unspoken ease
of access" in speaking as if we represent a group.
This linguistic arrogance represents more than an unrec-
ognized slip of purpose. It is the "indignity of speaking for
others" that Foucault so wisely warned us against.
When artists speak with such presumptions, it is an even
more profound acceptance of the growing kernel of
disastrous alignment between artistic critique and urban
renewal. We sound like city planners when we ask our
designs and diagrams to speak in proposal form for what
we imagine are the hopes of others.

The real failures for artists engaged with these issues seem to come about when we feel complacent about the methods through which an audience is presented to us. Who is characterizing this community for us? What agency is behind the picture? Sometimes just the description of a group itself as a receptive entity can cause a tremendous breakdown in the possibility of criticality. It seems this is already a danger that many artists are intimately aware of: the essential notion of the viewer of our work as being limited by his/her geographical location or his/her physiological character-istics or historical experience. Even though one must encourage the notion of common experience to give credit to collective resistance, the danger of pre-describing audiences and indignantly speaking for others is shadowing our practices. I believe these disheartening occurrences are manifestly embraced and latently encouraged by many official organizing efforts in the public art industry.

In the spring of 1994, Group Material was invited to participate in the Three Rivers Arts Festival of Pitts-burgh Pennsylvania, an annual conglomeration of musical and theatrical performances, craft sales, and art exhibitions. As a fulfillment of the public art component of this four-week event, the planners decided to embark on a "community based public art" initiative. We were encouraged to "find a community for our work" and to research neighborhoods in order to establish the social needs of a particular urban area or constituency. Our proposal was to use the printed program guide of the Three Rivers Arts Festival, fashioned to be inserted

into the local newspaper, as a site for the direct inter-
rogation of the conceptions of public art and audience
that I described earlier. In reading through its schedules,
essays, and acknowledgments, it seemed clear that
this program guide was the place wherein the "effect"
of the festival's work was meant to be communicated
to others, whether audience or sponsors. Implicit in
a program shaped by such a complex set of forces are
the phantom positions of the festival's many diverse
constituencies, from government agencies to corpora-
tions to art museum boards to private donors and groups
of volunteers. In the pages of the guide are written
the *explicit* ways we are to understand and demarcate
the space of the festival in relation to agencies that
manage, produce, condition and even own that space.
The printed guide then, is a kind of contract for partici-
pation. But *implicit* in such a contract is another meaning:
the implications of opening the public spaces of a city
to the desires of its inhabitants.

Our work attempted to obscure its own status
as art in order to further the mobility of its intervention.
We printed a series of quotations that were created
from interviews we conducted on the streets and
in the homes, cars and offices of people from Pittsburgh.
This was a technique very similar to the one used in
our *DAZIBAOS* project. We took out ads in local news-
papers asking for memories and secrets after which
we went on talk radio. We also interspersed quotes from
architects, critics and designers to bring the conversation
into a dialogic form. We were proposing that a con-
versation about different uses of the city can become

a public artwork. We wanted to consider the term "community" in relation to the festival itself.

A year before this work by Group Material had been produced, we went to Pittsburgh to witness the festival as an ongoing event. It became immediately clear that such an event has a schizophrenic relationship to the growth of the city beyond the expected and described paradoxes of urban renewal. Many official celebrations of cities walk a difficult terrain between privatized corporate sponsorship and governmental representations of social progress. On the one hand, the festival existed to serve the citizens of Pittsburgh as a vehicle for public expression of identity and culture, an agenda sincerely felt by many of its organizers. On the other hand, it needed to ameliorate and confuse

the complex social relations that made the ongoing project of urban renewal possible and by extension the agenda of public art production.

It became obvious to us early on that the only way to try to produce something critically generative in such a context was to try to make the whole public art process very conscious of itself. We tried to represent the struggle for identification and power that happens

within the normal business of the city's infrastructure as expressed in the ongoing problems experienced by a progressive arts agency, within and without the complex array of forces that make a city. In a sense, the guide to the festival would be full of suggestions, many even used by silent neighbors and secret friends, to how each of us can use the city differently than it was meant to be used. By quoting the memories, struggles, interpretations, and crimes connected with urban spaces we were trying to rewrite the syntax of a walk through the city.

We wanted to model tactical uses of the city that would counter both hegemonic design and limited uses of the term "community". The anonymous quotes in the program guide became a compendium of testimonials introducing a picture of a community that understands itself through experiences not identities, through expression not trauma. By interweaving this dialogue within the actual publicity material of the festival, we hoped to inform understandings of public space and to fuel active discussions about the struggle for self-representation.

What remains prominent in the public language of art agencies are descriptions of democratic developments in culture. Strongly informed by the institutionalization of community organizing, public art's misanthropic separatism from the real concerns of "everyday" reorients it from a supposedly elitist notion of audience to more democratic definitions of community. It may be understandable for institutionally identified practices and people to embrace remedial notions of disen-

franchisement. Many art agencies, for example, need
to take on the language of civic bureaucracies and phil-
anthropic agencies if they want to survive. But I think
it always seems disappointing when artists, who
have available to them descriptions of intellectually
independent and critical practices, succumb to limiting
descriptions of the relationship between our work and
the dream we call our audience.

I think the city from up high, the city as solely
a visual experience, is obviously one that we can see as
being manipulated by agency, gesture, or even whim.
Those who own the city have had this feeling from
the beginning, I would assume, especially in fast growth
cities as in the U.S. But the city on the street is the
physical entity many of us know. It is lived and created

111

through living: through the way space can be redesigned
and reused and even stolen to serve the needs of new
definitions of the self. Cities can be remade by wandering
around and acting out our own maps. By interviewing
both the consumers and the producers of public places,
Group Material wanted to demonstrate that one is
allowed to become who one is only through the way
space is arranged and defined. So performing differently—
using the city in a way not approved or representing
the forces that design the city critically—can provide new
propositions on the nature of the city's future.

There is a way in which official agencies can
never really make anything truly festive, and then there
is the way we pretend that they do in order to feel
that there is some way to participate. Artists must see

the tremendous contradictions of working with govern-
mental or corporate agencies that reinvent the public life
of an urbanism that increasingly belongs to fewer
and fewer people. Simultaneously, the reorganization of
desire by art agencies into replaceable economic
relationships hastens this limiting agenda. Perhaps these
public events are created by power more for itself
than the people attending. Surely it's not really about
convincing people of the false notions of progress
and humanization. That's easy. What's really difficult is for
power to act consistently in relation to itself, to convince
itself of its own faith in its immediate reproduction.
Paradoxically, the newfound institutionalized terrain of
community-based art practice often helps with this
legitimization and normalization.

For Group Material, the museum was always
as much a public place as the plaza or the street. These
are spaces where we represent ourselves to ourselves
and make meaning in a way that is open to the scrutiny
of groups and part of a social conversation. Increasingly,
there are fewer and fewer critical spaces that we
can move into and around in, spaces that present fluid
models of personality and affinities between people.
Many of the strategies used by artists in the past
have now become absorbed by forces in society that are
inline with urban renewal programs, forces that are
inimical to the progressive critical voices of complex
subjects. It is crucial that artists are aware of the
tendency of many public art programs to normalize us all,
both producers and participants, to a degree that we
become no longer public.

Arriving at Florida State University in early 1986 to talk about Group Material, I was met by Steve Kurtz, who taught there and cofounded the nascent Critical Art Ensemble. Over a long weekend, Steve interviewed me at his home for many hours and persuaded me to give another talk at a local bar. Although the practices of the two groups were different in many respects, the sense of urgency for a reassignment of social agency into art was immediately understood between us and grew over the years to inspire each of us in many contexts. This published interview, significantly edited from that initial conversation, indicates how two diverse practices of collective artistic labor in the 1980s were both consumed with producing new contexts for art across a wide range of social settings: in schools, bars, and the street as well as in art institutions. Subsequently Group Material and Critical Art Ensemble witnessed the increasing privatization of the everyday, enforced by the few over the many, multiplied repeatedly as our practices grew. But the aspiration described in this conversation, that artistic labor could provide resistance in the face of the economic reorganization of human life, somehow still continues.

**Group Material:** I would be lying if I told you that GM wanted to exist totally outside the systematic contradictions of the "artworld". We entertain the idea of galleries; we entertain the idea of critics and taste. To do otherwise is symbolic self-censorship.

**Critical Art Ensemble:** Existing outside a system isn't possible anyway.

**GM:** Of course it's not. Don't we have to live with the imperfection of how collaboration is viewed in those structures? It's an anomaly.

**CAE:** Yes. You have to work within the gallery system, and also you don't want to strip the gallery audience of the chance to see the work by categorically rejecting that system either. I have never viewed GM as trying to undermine the gallery. Rather, it's at times participating in the same project as CAE—changing artists' conceptions about where it is legitimate to show and where it isn't. Actually, you can really show anywhere. You don't have to just do the gallery, which is just a single option, not the only option.

**GM:** Just a specific one that should be researched and understood.

**CAE:** And the issue that you have also brought up here is that one must know that the gallery system is the infrastructure of the art community. It can't be ignored.

GM: The real irony is that many oppositional stances to a system seem as much a part of it as anything else. Like the recent history of the alternative space. It's as if these spaces have a guaranteed separation from a commercial order, when in fact they are often the proving grounds for commercialism. This is not an automatically bad thing, of course. I mean, I try to promote work that I think is important whenever I can.

CAE: Why did Tim Rollins recently leave Group Material, just as the press began to focus on him as a pivotal person in the group?

GM: We all have jobs and our own art practice. At this point, certain levels of production and effect for Tim and KOS now have the potential of happening. For him not to take advantage of this would be foolish. For others to criticize this as careerism would be too easy.

CAE: I'm just saying that the way the situation looks now to those outside of NYC, who are receiving information filtered through the press, is that the journals and the marketplace were looking for a dominant signature, and Tim was the signature that became associated with GM. There is nothing wrong with the organization itself; a signature is something that the market is going to fish for, and that is why I was wondering, is Tim leaving as a reaction against this market misrepresentation?

GM: No. There have always been misrepresentations. Part of it has been because of our own sloppiness and

part because of how people are. Institutions need the signature and it's hard for them to look at collaboration with its demands on authorship. Of course the failure of many writers to comprehend our project is predictable, but if we are going to judge our culture only through Art Forum then we deserve the culture we get. If you want to pick on how GM has been misrepresented in many ways, as with the treatment of Tim, you should also ask about all the other ways it has been misrepresented.

CAE: Such as?

GM: That we are all curators. We are not curators. We are artists who are re-presenting other people's work in a context that is making another statement entirely. Another misunderstanding is that it's all pedagogical. That went on for a while. That has chilled out, but the belief continued for a while that we were all teachers, and that GM was involved in some kind of educational research. Two of the members of GM were not teachers. This is like saying we're doing psychic research, because one of our members happens to do readings for people on a professional basis.

CAE: Is there anything you else want to say about the disadvantages or advantages of the use of collaboration, as compared to more mainstream styles of art production?

GM: Well, this might sound a little bizarre, but I really don't believe that anyone today is working alone with his

muse in the garret. I don't think it's possible any more. (I do think that some people believe that they are working in a purely personal and special way.) Information has taken on a universal level where you are never really working by yourself in the same sense that you can't think politically by yourself. You can't not pay your taxes and you can't not have a checkbook. You can't not have a social security number. Welcome to Modernity.

CAE: So your basic assumption is that art is a social institution that can only function within a social milieu.

GM: Yes, I've always assumed that's a given.

CAE: Is the collective method on the rise?

GM: To collaborate isn't enough. Our proposal wasn't that we would necessarily change the relationship between audience and author just by saying, "We're not an individual artist." We wanted to truly effect the social relations that surround the production and distribution of artwork. I still have questions about the levels of consistency I see in other collaborative practices. It's like the methodology is hidden. If GM chose this strategy I don't think we would have gotten such variety of certain thematic involvements with the world. I don't think you would have gotten as many different positions and involvements with such high levels of complexity from political and cultural groups within any one exhibition. Really, the diverse nature of our product is due to our process.

CAE: But that is why a collective is necessary. A person can only specialize, speak, or produce in a limited number of realms with any authority. After that you have to rely on other specialized backup.

GM: My problem with this is that even though I know that a lot of GM's uniqueness is due to the collective method, I don't want to stress method over product. GM has always tried to inform its projects with the expertise and voices of others.

CAE: That's why I see the collective experience, the collective method on the rise. It has to be, because of the massive amount of information that exists; history affords us no other choice but to begin cultural production on a larger scale, with more people and a greater amount of specialists. I would be very shocked if you said to me that the collective method was on the decline.

GM: Yes, but collaboration is the method of many modern agencies, not just progressive or populist ones. This is what law firms do, what museums do. Artists were always kept in the dark about this stuff! My hope is to make collaboration something that can oppose traditional hierarchies of labor that seek to manage what we produce.

CAE: What do you think about specificity in political art? There is so much art that addresses current social issues within the frame of given responses and data

filtered through the media. It is art that is without informational resources, and how can such work have any more credibility than the evening news?

GM: It would probably have less credibility, but I don't think that serious artists working with public agendas are really trying to compete with Dan Rather. The problems begin when artists are content with his quotes.

CAE: Because if you are just quoting something learned from the media, all that is really being done is quoting a re-presentation of what is happening.

GM: Or a cause of what's happening. This brings us back to methodology and the artist. A lot of political art does the same thing with content that expressionist art does with emotion. That is, it takes this issue and says, "I'm going to paint some dripping red letters, and some screaming children and then I'm going to be a political artist." In contrast, what GM has been trying to do is diagram different social forces, such as in the show Timeline, which was informed by working with the Committee of International Solidarity of the People of El Salvador, Taller Latino Americano, Casa Nicaragua, and others who brought information from sources radically different from the dominant media. Without them and chance meetings with artists and intellectuals who were here in exile from Central America, our work wouldn't have been possible.

Actually, our relationship with these groups began two years earlier with a show called *Luchar*. There were

things in that show from Mexico City, from Salvador, from Managua, that we displayed next to Leon Golub, Martha Rosler, Mike Glier, etc. The opening turned into a kind of mass meeting between artists and activists. There were speeches by Lucy Lippard and the NYC representative of the FDR/FMLN. An organization of El Salvadoran artists and intellectuals was founded. There was a kind of reciprocity, with people's agendas informing various artistic practices and the art exhibition becoming the springboard for political organization. And it didn't end there. Two years later we saw Artists' Call Against U.S. Intervention in Central America organize cultural professionals as a group around this issue across the country, to actually affect our industry.

CAE: What is the artist's responsibility to the community?

GM: Our exhibitions and projects gather different levels of cultural production into one site. By doing this we are automatically serving more artists and audiences than the mainstream. A lot of specific shows have had specific community concerns; a lot them touch social relationships in the way the artwork is perceived. In other words, why can't an art show be organized that has a different level of concern besides the specialized artist? A show like *People's Choice*, which was an exhibition of artworks and artifacts in the early GM space, was obviously working out of a concern for the neighbor-hood of the exhibition space rather than for art-trained professionals.

CAE: Did you have good community turnout for
*People's Choice*?

GM: The group went door to door asking people for their
most beautiful paintings, their most important pictures.
(This was before my time. I was still a student and part of
GM's enthusiastic audience.) It was obvious to everyone
that People's Choice was the most important show
that the group did during that period, because it totally
transformed the supposedly neutral gallery into an icon
of the neighborhood. The show wasn't based on what
the "experts" thought best represented the neighborhood.
These objects were what the people on the block valued
as beautiful.
　　Back to our conversation about specialists:
You see, merely collaborating with others will not confront
the destructive nature of an increasingly privatized
culture. The specialist might be the very audience that
for so long has been locked out of the industry. In *Luchar*,
the specialist might be the designer making posters
in Salvador—literally on the front lines of conflict—whose
life depends on it.

CAE: When you did the subway piece did you ride on
the subway and see what the response was? Were people
just reading their Daily News or actually paying attention
and reading the GM pieces?

GM: We chose those particular ads in the subway,
just above eye level, because people really do read them.
If you get on and it's crowded, you can't read the paper.

There's also the "don't look at me and I won't look at you" routine on the subway already. In that kind of social space, you look up, where *Subculture* was installed.

CAE: You can't do better than that when you penetrate the unspoken part of everyday life.

GM: At that time the subway was a radical site for the installation of "public" art. And already culture in the trains is becoming standard institutional fare with artists getting commissions from the transit authority.

CAE: Was it part of the agenda for *Subculture* and *DA ZI BAOS* to disrupt everyday life structure?

GM: Yes and no. I don't think that it's necessarily any more of a disruption than the normal level of media onslaught that we have to live with. The idea with Subculture was that through some level of collectivization, the pooling of resources, any individual can intercept that onslaught, can participate relatively; it was no big financial deal because each artist in the show covered the costs of producing a series of images. We paid the installation fee and dealt with the bureaucrats.

CAE: Wouldn't such installations necessarily have an alienating effect since you're breaking habituation. What you put on the subway wasn't a hemorrhoid ad.

GM: Some work mimicked the advertising almost to the letter, and I'm sure that it was read with the same

sort of psychotic level of consumption that just goes through you. But my feeling still is that some of the most successful work was the painting, because painting in that context was really shocking. An artist named Amanda Church did twenty-seven identical paintings of a woman running from a burning shack in the middle of a field. It was a learning experience for me. Here we were, really talking up the authority of graphic forms and asking everyone to keep in mind the corporate aesthetic and content of most subway advertising, and when we got it all up on the trains . . . we learned that the paintings in many ways were the most dangerous.

CAE: Do you find that shows work better outdoors, where you make the first move to engage the audience, with perhaps People's Choice not withstanding?

GM: Let's remember that just because art is placed outdoors, that doesn't make it public. Group Material has tried to approach the relationship between artists and audiences on two levels, among others. Some projects have enlarged the capacity that the gallery has to represent different aesthetic agendas—*People's Choice* was an example, but so is Americana. By exhibiting household appliances at the Whitney Museum we were pointing out that curators aren't the only people that make aesthetic choices. Other projects have tried to expose these agendas to other artists. In *Subculture* we asked, "What kind of work would you make for a subway?" and in Timeline we asked, "What kind of work would you make to chronicle our government's military intervention?"

CAE: Is GM going to take these shows out of urban areas, and thereby changing the context in which they are presented even more?

GM: The *DA ZI BAOS* project, where we interviewed institutions and individuals and compared them at a public level on large-scale poster work, should be done across the country. We have done it in Wales because we were invited to do it by an organization there. I would love that every time we go someplace, like here in Tallahassee, to produce *DA ZI BAOS* in response to local issues. It is still planned to do this at nuclear dumpsites in a place like Montana or New Hampshire, one of those rural towns where 60% of the people are unemployed and a local government can say, "All right, we'll dump here, and we'll all get jobs and the city will garner a lot of tax revenue." Of course not everyone says yes.
What these issues produce is often a level of participatory democracy that is at best rare in urban politics. The town meeting, for Group Material, is a particularly relevant cultural process. And it's fascinating how this American institution, this tradition, can be paralleled with a project modeled after the *DA ZI BAOS* (large character posters) of China's Cultural Revolution.
There is something here about GM's project that I think should be mentioned, because it is important to understand in taking on this kind of work. That is, try not to become satisfied with the opportunities and offers. Throughout the life of the group we've tried to balance invitations with self-initiated works like DA ZI BAOS. One has to remember that any agency, not

just the patron, can become an ideological taskmaster. And meanwhile, the mayor of "anytown" isn't on the phone as we speak, ready to say, "We really like you guys. Why don't you come over and hook up one of those *DA ZI BAOS* for us?"

Activists should do Documenta. We should do the Whitney Museum, not only for their audiences but to reach a level of institutional notice that helps develop other audiences.. Barbara Kruger has been saying this for years and recently has been attacked for her so called "commercialism." But as I said when the tape was off, whether you love or hate the idea of Mary Boone isn't the point: Barbara's billboards are up in little towns across the country. *We Don't Need Another Hero* was up in Philmont, New York, the home of Oliver North. It wouldn't have happened if she had decided to resign herself to some naive idealist idea of populist art that rejected every capitalist organ of production.

CAE: We've touched on theory, so while we're on this subject, let me ask you about *Resistance (Anti-Baudrillard)*. Why did GM feel so strongly about the use of Baudrillard's theory that you had a show against him? And how much of it was homage to him?

GM: It was not an homage. It was not against him. What GM wanted to do was to take the Baudrillard we had used in the past, the Baudrillard of The *Mirror of Production* and *Critique of the Political Economy of the Sign*, and compare him to the art world's love of image that was so apparent at that time. Resistance

wasn't about Baudrillard the person or even directly about his writings for that matter. It was about how critical factors in our industry become complicit with status quo visions of culture and history, a complicity I think we all experience. Even Baudrillard himself got up in public to declare, "My critical work is not about art."

CAE: Most notably at the Columbia lecture.

GM: Right. What we were interested in with *Resistance* was how a contestational theory was being used and abused, and to question that use through the exhibition of different kinds of artifacts. We grounded the whole exhibition on video. We had three monitors that were to act as a triumvirate ground of how through media politics are sublimated into everyday life. The objects in the show covered a spectrum of oppositional strategies artists can adopt, from producing graphics for SWAPO (the South African People's Organisation) or local New York labor unions, to making work in the gallery like Mike Glier, Hans Haacke, Nancy Spero. Also, we tried to show historical precedent for this kind of process: Heartfield in terms of the activist, Odilon Redon in terms of the dream, Catherine Allport in terms of photojournalism. You see, if Ashley Bickerton is suddenly proclaimed a "contestational" artist then what kind of artists are in Guerilla Art Action Group?

CAE: So it seems that you were much more worried about (at least at that point) the massive proliferation of simulationist art that was all grounding itself in a mis-

representation of Baudrillard's theories, rather than in Baudrillard's theories themselves.

GM: Yes, that's it but, well, look, there are massive holes in the later work. If social science is science fiction, then that means that all the work in the simulationist program is what all the academics (who are eating the shit up) say it is. But I don't think that Baudrillard is right, and my students at Bedford-Stuyvesant don't think he's right, and I hate to sound corny, but the campesinos in Nicaragua don't think he's right, and eighty percent of the people who have ever struggled to try and change the fuckedupness of this world don't think he's right.

I'm pretty convinced that using a theoretical model based entirely on language is a mistake. As artists, we leave the social relations and social determination out of this again and again.

CAE: So are we back to the Critical Theory School?

GM: Not necessarily. Although a re-reading now and then can't hurt. Let's use post-structuralism as a tool, use it as a way of deciphering habits and stories, in a way that might expose the social forces that lead to the inability to read in the first place. Why this author? Why this meal? Why this kind of coffee? Let's use Barthes to find out how the world is built as a series of mythologies, and then try to find out why these mythologies were built and maybe more importantly, who built them.

**CAE:** Do you think that the GM *Resistance* show did counter the practice to some degree and change the use of Baudrillard by the NYC art community?

**GM:** Other things happened that make it OK now to say, "I hate Baudrillard," but it certainly wasn't because of us.

**CAE:** I see it as a milestone show because it did help to bring legitimacy to saying, "I hate Baudrillard," to the critical literature as well as to the art community. GM took a major step towards eroding what I see as a fashionable use of artificial rhetoric to justify what is at best mildly critical work.

**GM:** Forget Foucault, fuck Baudrillard. Let's be careful here because there are two traps in this part of our conversation that we have to avoid. Even though GM is committed to practical models—to actually doing things— we're not anti-theory. Let's not feed the traditional delusionary practices that avoid theoretical contradiction. Dripping red letters are not working.

The second trap is giving in to the abuse of theory, especially in the art historical world. Recently, in the past four or five years, there has been a lot writing around the idea of a resistant postmodernism. This work, even if outlining an excellent theoretical program, continues to ignore many of the practical models that surround it. There is a whole terrain of cultural production— collaborative, community-based, pedagogical or just plain sub-cultural processes—that won't fit into the "fine art"

category." Here I might sound like a traditional Marxist, but I feel that the reason these models are ignored has to do with class comfort, with risky theory over resistant practice.

CAE: It seems that you see the theory-praxis problem as completely unresolved, despite all the rhetoric of the French Marxists that theory is praxis. Do you still have questions about the problem?

GM: In our industry it is certainly a mess. I mean, we both know how rare it is to read something that can both reflect the sense of beauty and the history that one can find in an art object or other cultural moment. Recently, GM has tried to have writers who usually address other disciplines and audiences become involved with our project. For Constitution we published essays by Judge Bruce Wright, a federal judge in New York, and Michael and Margie Ratner, from the Center for Constitutional Rights. We really wanted to supply something a little more useful than the usual promotional stuff. We all have to remember that the specialized art community, as an intellectual sphere, is a very unusual place and always has been.

CAE: At least since the nineteenth century.

GM: It's been a site of relatively incredible intellectual mobility. Even here in Tallahassee, it's like a minefield of cultural production, half brilliant and half shit, but none-theless creating a discourse and an audience for

ideas that other fields rarely match. Or look at Artists Call Against U.S. Intervention in Central America which was able to use the entire institutional framework of the art world to raise money on a totally practical level. Here was a group, of maybe fifteen or twenty in New York, using the market structure to do real political work. Real resources were raised for real struggles.

CAE: What are the information options for those not wanting to read theory?

GM: Well, lets take this supposedly theoretical idea of "appropriation." With the high school kids I teach, there is an intrinsic knowledge about appropriation, because for them in a sense, all cultural production has to be stolen. White culture historically never let you proclaim the culture that you had. It's not talked about, it's not taught, it's not on TV. And even within a group of young artists for graffiti writers, to bite something and make it your own is a sign of greatness. Tap dancers build whole repertoires of stolen steps. There is the idea within folk culture of how imagery gets communicated, appropriated, and turned into new imagery.

CAE: So everyday life communication is one of the best sources at that point. Just looking around and seeing the everyday life situation.

GM: "Situation." There's that word again.

CAE: After '68 it endlessly comes up.

GM: Let's hope so.

CAE: It seems that in your former answers, as in your explanation of *Resistance*, that the issue of fashion-consciousness is touched upon. Theory has never been as fashionable as it is right now, and one of the main reasons is that many of the major breakthroughs have not been in art, but in criticism. Criticism is rapidly developing while art spins its wheels in the muck of a redundant pluralism.

GM: I might agree with you about theoretical developments if it was possible to really isolate them. There is the possibility of addressing a whole range of human activity but there still is the problem of marketable and unmarketable criticism. There has always been writing that fits into gallery programs, produced by those who are bought and sold in the same muck that you mention. We know who they are now, and who they were last year. You only have to open an art magazine to see this perfectly ordered lexicon of the market.

Also I think it depends a lot on which side of the fence you stand on. I mean, some people have described Hal Foster as the dominating maestro. Oh, please! Here we are at a theoretical flashpoint and all some can do is shout "traitor." Meanwhile, Cornel West is speaking at art world institutions, Doug Crimp is editing an issue of October on AIDS, and Lucy Lippard is more important to read than ever. I'm optimistic.

CAE: Tell us about the Inserts project that you tried to get in the New York Daily News just recently.

GM: It's not unlike *Subculture*, our project replacing advertisements in the NYC subway. Group Material feels that these huge organs of the public expression world should be approached for disseminating artwork. Another project, *Inserts*, will be a twelve page advertising supplement for the Sunday paper containing ten artists' works, developed specifically for this context. It will reach about 200,000 readers in various neighborhoods of the city. This time I feel we're really building a bridge between public funding and a program of dissemination that actually reaches people. Public agencies don't have to limit themselves to supporting the same old pedestrian blockers, lobby fillers or museum blockbusters. I understand from talking to Jenny Holzer that a lot of TV channels will sell late night ad spots for peanuts. Can you imagine the audience?

CAE: So it's the audience size that interests you the most in using this medium?

GM: The size, and the method of address. There are all these resources being spent on the reproduction of artwork—why not make a catalog that exists in the public sphere instead of in the alternative art space? How do we think in these spaces?

CAE: What can we expect in the future from GM?

GM: We're working on a project called *Democracy*
that will take place at the DIA Art Foundation next fall and
winter. It will be a five-month series of exhibitions and
meetings that will examine the current crisis in American
democracy. In a way this is a dream come true—
a chance to rigorously involve other voices in our working
process. You see, as great as I feel GM's contribution
so far has been, it usually has been a spectacle of
relations between different communities. In other words,
just because you show a Thomas Lawson painting next
to graphics from the Redistribute America Movement
doesn't mean that these two kinds of producers develop
any working influence, or even acknowledgment
for that matter. Of course it happens, but the exhibition
in itself remains a model of possibilities instead of actual
organizing tools.

Anyway, with *Democracy* we've planned a series
of roundtable discussions for artists, critics, policy-
makers, and theorists that will both inform the exhibition
and establish agendas for public town meetings
coinciding with the show. We're trying to replace the
traditional lecture/panel method of presenting information
with a more public method. Each show will be surrounded
by the social forces that make such art possible in
the first place and each discourse will be exemplified
by the cultural work it implies. A book documenting this
whole process will be distributed by DIA afterwards.

To me, what's really important is how all this
is going to affect history. I don't mean to sound egotistical
about it, but ten years after witnessing the beginnings
of GM as a member of the audience, I'm finally realizing

135

## Thanks

The sculptor Reuben Kadish taught me many years ago that every artist is in some kind of communion with the artists who came before them and, although not "here," these distant minds are reproducing us every day in the present. This publication is for Peggy Ashford, the very first artist I ever knew.

Seeing these writings out of context and collected into a new edition has provided me with absolute proof that no thinking happens alone. In my particular case, as someone who struggles painfully with writing, it is always the work of other people that has made my thoughts legible. I am grateful for the editorial direction of Maria Lind, Prudence Peiffer, Karen Kelly, Josiah McElheny, Angelo Bellfatto, Julie Ault, Richard Embray, Naeem Mohaiemen, Thom Donovan, Peter Eeley, Melanie Franklin Cohn, Steve Kurtz, and Miwon Kwon. Each of these remarkable thinkers has made one or more of these essays possible or began a conversation that has turned into this writing. Claire Grace fluently read through the first draft of this collection and gave me a sense of how the works actually might relate to each other. She did this with such compassion and insight that I now actually look forward to writing in the future. Divya Ghelani's precise final proofing has made the whole thing read as one.

Krist Gruijthuijsen's articulate understanding of abstract form's relevance to public life has been something to treasure. If I am one day able to reproduce half the insight he has shown me in working near him, I will be very happy. Finally, the production of this volume would not have been possible without Alyse Yang's bright mindfulness.

Doug Ashford

Original Publication Citations

Critical Art Ensemble, "Group Material, An Interview,"
*Art Papers*, Vol. 12, No. 5, September-October 1988, 24–29.

Doug Ashford, "Notes for a Public Artist",
in *Public Art is Everywhere*, (Kunstverein in Hamburg and Kulturbehörde
Hamburg: Hamburg, Germany, 1997), 110–125.

Doug Ashford, "A Boy in the Park, or, The Miniature and the Model"
in Wolfgang Tillmans, ed., *Jochen Klein*. (Walther König: Cologne, 1998),
89–92.

Doug Ashford, "Airport Photos,"
*The Saint Ann's Review*, Spring/Summer 2000, 144–148.

Doug Ashford, "Finding Cythera: Disobedient Art and New Publics,"
in Melanie Franklin Cohn, ed., *Who Cares*. (Creative Time: New York, 2006),
14–20.

Doug Ashford, "An Artwork is a Person,"
in Julie Ault, ed., *Show and Tell: A Chronicle of Group Material.*
(Four Corners Books: London, 2010), 220–225.

Doug Ashford, "Empathy and Abstraction" excerpted from:
Angelo Bellfatto and Doug Ashford, "Sometimes We Say Dreams When
We Want to Say Hopes, or Wishes, or Aspirations," in Johanna Burton,
Lynne Cooke and Josiah McElheny, eds., *Interiors.* (Center for Curatorial
Studies, Bard College and Sternberg Press: Berlin, 2012), 88–109.

Maria Lind, "New Objectivity, Maria Lind Talks with Doug Ashford,"
*Artforum*, March 2013, 147–148.

Colophon

Writings and Conversation by Doug Ashford

Published on the occasion of the exhibition:
Doug Ashford
Grazer Kunstverein, Graz, Austria
September 21 – November 24, 2013

EUR 15 – USD 18
ISBN 978-88-6749-075-2

Editor: Krist Gruijthuijsen
Text: Doug Ashford, Krist Gruijthuijsen
Photographs: Doug Ashford, except images on pp. 13 and 65
Design: Marc Hollenstein
Copy edit: Divya Ghelani
Printing: Offsetdruck Dorrong, Graz, Austria
Edition: 1000 copies

Publisher:
Grazer Kunstverein
Palais Trauttmansdorff
Burggasse 4
8010 Graz, Austria
T +43 316 83 41 41
F +43 316 83 41 42
office@grazerkunstverein.org
grazerkunstverein.org

Co-published by Mousse Publishing
Via De Amicis 53, 20123 Milano, Italy
moussepublishing.com